The Fish House Book

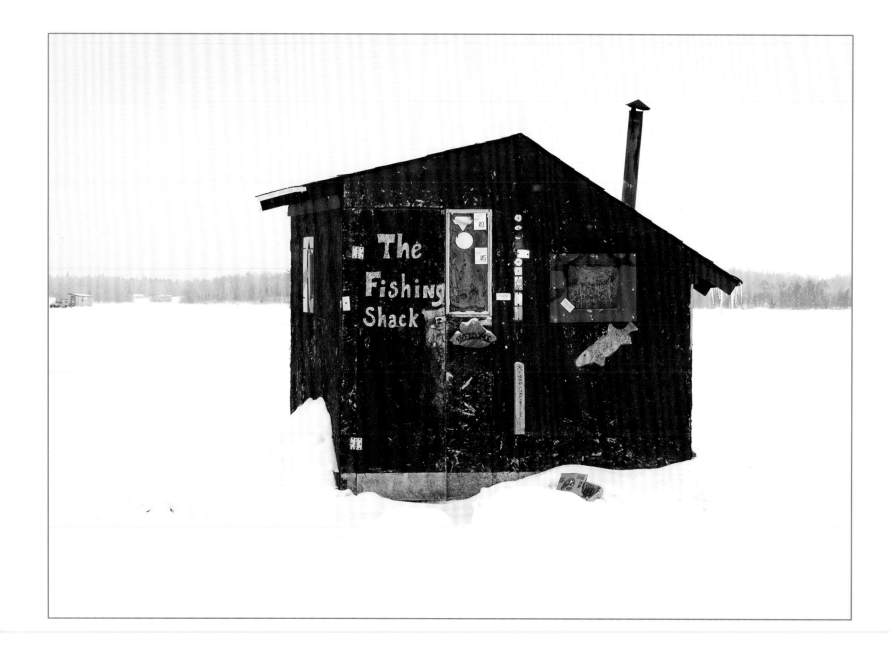

The Fish House Book

Life on Ice in the Northland

Kathryn Nordstrom

Essay by Arnold R. Alanen

Dovetailed Press LLC
Duluth, Minnesota

Copyright 2007 photos and text by Kathryn Nordstrom
welcome by Marty Glorvigen
essay by Arnold R. Alanen

First Edition

ISBN 13 ~ 978-0-9765890-2-0
ISBN 10 ~ 0-9765890-2-8 Library of Congress Control Number : 2007921885

Book layout and design by Kathryn Nordstrom and Marlene Wisuri
Cover photos by Kathryn Nordstorm

Printed in China by Pettit Network, Inc., Afton, Minnesota

Publisher's Cataloging-In-Publication
(Provided by Quality Books, Inc.)

Nordstrom, Kathryn.
 The fish house book : life on ice in the northland /
Kathryn Nordstrom ; essay by Arnold R. Alanen.
 p. cm.
 Includes bibliographical references.
 LCCN 2007921885
 ISBN-13: 9780976589020
 ISBN-10: 0976589028

 1. Ice fishing--Pictorial works. 2. Fishers--
Dwellings--Minnesota--Pictorial works. I. Alanen,
Arnold R. (Arnold Robert) II. Title.

 SH455.45.N67 2007 799.12'2
 QBI07-600112

Distributed by: **adventure** PUBLICATIONS
820 Cleveland St S • Cambridge, MN 55008
www.adventurepublications.net
1-800-678-7006

Dovetailed Press LLC
5263 North Shore Drive
Duluth, MN 55804
www.dovetailedpress.com
www.fishhousebook.com

Dovetailed Press LLC

❄ Dedication

To my grandfather, Wilfred Wisuri Sr., who loved to ice fish.

His well-used Mora ice auger, with its handmade guard, is a family treasure.

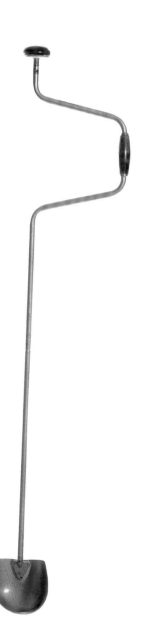

❄ I would like to thank...

❄ Marlene Wisuri–this book would not have been possible without your knowledge, guidance, and support.

❄ Dick and Elaine Nordstrom

❄ JoAnn Jardine

❄ Sportsman's Sleepers –Sheri and Dan Gibbins

❄ Al Christianson–Brainerd

❄ Mark Rodio

❄ Phyllis Lyback–Lyback's Ice Fishing

❄ StrikeMaster Corporation

❄ All of the great, friendly fishermen and women who opened their fish house doors to me and my camera. Thank you for sharing.

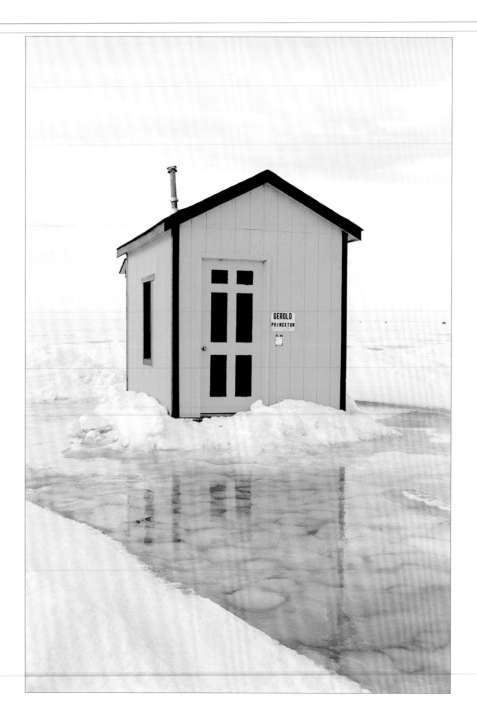

❄ Table of Contents...

Message from a Pro by Marty Glorvigen 8

Introduction by Kathryn Nordstrom 9

The Lure and Lore of Fish Houses and

Wintertime Fishing in the Midwest

 An essay by Arnold R. Alanen 12

The Fish House Photographs 22

Catch of the Day 126

About the Author 128

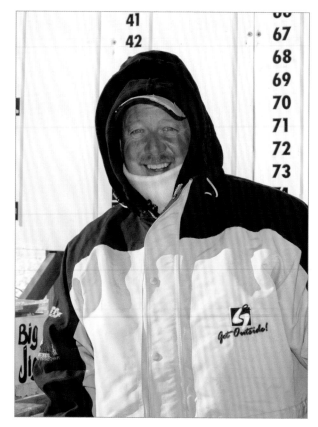

In the northland life is about being connected to the outdoors. Our heritage is to participate in the seasons and many northlanders favor fishing. I, like most, have spent a lifetime on the waters— fishing, solitude, companionship, and enjoyment keep me wanting more. True northlanders do not give up their passion at season's end; they merely change modes of participation. Boats get stored and ice shelters get built.

Those of us who pursue many species of fish pull out the ergonomically-designed, super-efficient, flip-over shelters that are compact and mobile. Those who are in search of companionship and/or solitude drag out fish houses of all shapes, sizes, and colors. They become places of refuge on cold winter days and retreats in which to enjoy family, friends, and fishing.

In *The Fish House Book: Life on Ice in the Northland* you will get a chance to see how life on the ice is truly a warming experience!

Marty Glorvigen

Marty Glorvigen fishes professionally with his twin brother Scott. They are hosts of the Pros Pointers television spots for Gemini Sport Marketing. Marty is pictured serving as a host of the 2007 Big Jig Ice Fishing Contest and Festival, an annual fund raiser for the University of Minnesota Duluth athletic department, held on Pike Lake near Duluth, Minnesota. The 2007 contest drew over 1,300 anglers.

❄ Introduction...

While on my way to a photography seminar in Alexandria, Minnesota, with my studio partner, JoAnn Jardine, we drove past one of those perfect scenes. The sun was soft and beautiful, the snow sparkling and the fish houses striking in the light. We wondered if anyone had documented with photographs or published a book about fish houses and we talked about what a great project that would make. That was the seed that started this book and my journey on ice.

I grew up fishing at our family cabin outside of Grand Rapids, Minnesota. I dug for worms and loved to bobber fish off the dock or the pontoon for bluegills and crappies. Grandpa patiently filleted all those fish and my grandma fried them up in beer batter. I can still taste them. By that time, my grandpa's green darkhouse had become a shed that housed our sand pile toys, so when I began work on the book, I had only ice fished once. I'll admit that I wasn't that impressed. I was approaching fish houses from an artist's and a neophyte's point of view and I was ready for an adventure.

My photography was based on exploration and documentation. What about those houses? What did they look like inside? What did people do out there miles away from shore? Documentary work was something new for me after pursuing fine art projects that included photographing set-up, 3-D scenes and abstractions. This was active, outdoor photography with quick changing and sometimes-difficult conditions. I also believed these images would become an important historical record, as more and more houses are purchased prefabricated.

I'm bundled up and ready to photograph on Upper Red Lake.

My first trips to Lake Mille Lacs and the Brainerd Extravaganza opened my eyes fast to how big the sport of ice fishing was and how broad the culture. A whole other world existed out on the lakes in the wintertime. What I originally thought would be a book just about houses, needed to broaden in scope. Over my four winters of shooting, I have had wonderful experiences learning about the great people, houses, fishing, fun, beauty, and solitude of our Northland.

I came to terms with driving on the ice roads quickly. I needed to cover a lot of territory and four wheel drive was a necessity. I almost always traveled solo (not recommended for safety) and only two times was I uncomfortable. The first was when I stupidly drove out on fresh, deep snow with only a pickup truck track, extreme cold, and the moon rising on Chub Lake. I was so thankful to get back to shore. And the second was on Lake Minnetonka. I had checked first with the locals because of questionable conditions, but had never heard the ice crack like that while I was driving. While my heart was pounding, I took my shots and headed straight back to land.

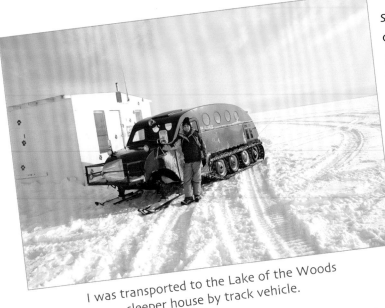
I was transported to the Lake of the Woods sleeper house by track vehicle.

Weather conditions offered ever changing shooting situations. Most often the sun brought cold and a frozen face and fingers. However, one memorable sunny thaw day saw temperatures in the 40s and water on the ice roads and around houses. It also brought the fishermen outside of their houses to enjoy the rays. Another day I was trapped in a snow squall on Upper Red Lake minutes after driving out onto the ice. I tried to make the best of it and shoot a few pictures, but it became impossible as the houses quickly turned into blurs of white. It took a long time to drive back off the lake and I was thankful for the daylight and orange road markers.

I knocked on a lot of fish house doors and I can attest to all the friendly and gracious fishermen and women out on the lakes. After explaining what I was doing, I was always invited in to talk and take photographs. I woke someone up from a nap, was offered many a beer, updated on the fishing, given information about their houses and families, and leads for other interesting houses. I really appreciate all those people who shared their passion for ice fishing with me.

I had an amazing time at Lake of the Woods staying in a sleeper house. I was driven over 10 miles out onto the lake in a Bombardier track vehicle to a house outfitted for fishing, cooking,

and sleeping. I photographed a beautiful sunset and relaxed in the quiet. I fished through the evening and realized that if I caught a huge eelpout I would probably have to throw it outside—pole and all, because I wouldn't take it off the hook myself. Unfortunately, I didn't catch anything. Up at sunrise, I was out in the frigid air to witness the incredible fish house mirages on the horizon. Later I shared a ride back with a family and their young daughters who had spent two nights out on the lake on vacation.

During my first year on the project, I took a helicopter ride to photograph the Jaycees Ice Fishing Extravaganza on Gull Lake. I knew I wanted to return to Brainerd as a contestant. I was one of over 11,000 people angling for prizes, which included a new truck. I still can't believe what a spectacle all those fishermen made on the ice. I had never seen so much Carhart all in one place. I took many pictures and met some guys from my neck of the woods. I caught one little perch and a neighboring fisherman teased me that it must be my bait, not a catch. The wind had been very cold—no shelters are allowed—and I was happy to get on that yellow school bus shuttle for a ride back to my car.

Kathryn Nordstrom

ADMIT ONE CONTESTANT
(MUST BE DISPLAYED IN PLAIN VIEW)

00017583

2006

January 21, 2006
12:00 Noon to 3:00 P.M.
Gull Lake - Brainerd, MN

$10.00 Random Drawing Tickets will be sold on the ice and at local distribution sites. Feel free to use these labels when purchasing tickets.

My companion dog Devi braves the crystal clear ice of Lake Superior.

I loved the search for houses. There are so many different kinds which reflect so many personalities. It was a nice change of pace from studio work and I never knew what I would end up finding on each drive. Time on the ice was special for both creating and finding a unique peace. It is easy for me now to understand the appeal of ice fishing and the attraction of spending time at your house. It makes me think back to my childhood fort-building days, only these "forts" are out on a frozen lake. There you can fish, escape, hang out with friends, meditate, eat good food, drink some beer, play cards, work on your house, fish some more… I hope fishermen and non-fishermen and women alike will enjoy these photographs and learn a little more about fish houses and life on ice in the Northland.

Kathryn Nordstrom, June, 2007

The Lure and Lore of Fish Houses and Ice Fishing in the Midwest

What could be more quintessentially Minnesotan or Midwestern than fish houses, those diminutive structures that appear on frozen lakes and ponds during each winter fishing season? Whether called fish houses or ice houses, fish shanties or ice shanties, fish shacks or ice shacks, ice huts or fish huts, these buildings are not a prerequisite for wintertime fishing activities; nevertheless, many anglers regularly employ them to secure protection from winter's harshest elements.

The Midwest—especially Minnesota and Wisconsin, two states with more than ten thousand lakes each—serves as the heartland of winter fishing and fish house culture in the United States. Indeed, in Minnesota more than 156,000 fish house permits were issued in 2006 alone. Fish houses are so heavily concentrated on some lakes that they even give the appearance of temporary towns laid out along well-plowed ice roads and streets. The fish-house town that emerges on Minnesota's Mille Lacs Lake each winter, for example, can have as many as 6,500 structures that accommodate thousands of anglers who sleep overnight in bunks situated just above the lake's icy surface. It is important to emphasize, however, that ice fishing is not limited just to Minnesota and Wisconsin; it is a popular phenomenon that also occurs along a northern band of states stretching from Maine to Idaho, and is evident throughout much of Canada and Alaska. Overall, an estimated fifteen million North Americans engage in ice fishing each year. Elsewhere, the Nordic nations of Finland, Norway, and Sweden, as well as Russia, are important ice fishing regions.

Fish houses are typically small in scale and simply built. Because of their utilitarian and functional features, they serve as examples of what scholars term "vernacular" buildings. But even though the form and construction of fish houses may be basic, a rich tradition of folklore, common sense, and science is associated with them. Ice fishing, in fact, often serves as the stuff of legend, and many of its practices are imbued with substantial doses of humor and levity. As revealed by the images that comprise the body of Kathryn Nordstrom's book, some fish houses are so unique and idiosyncratic that they may even be identified as "folk art on ice."

The Practice and Philosophy of Fishing Through the Ice

Wintertime fishing does not require many of the expensive trappings that define summertime angling—namely, boats, outboard motors and gasoline, and boat trailers. The fisher first chips or drills a four- to twelve-inch hole in the ice, a task formerly undertaken with a hand-driven auger or chisel, but now accomplished by a chainsaw or power auger. Also required is some sort of apparatus to hold the fishing line, which might be nothing more than a simple "tip-up," a tool that supports the mechanism holding the reel of fishing line, or a rod and reel fabricated of highly technical materials. Bait is an obvious necessity and can consist of natural lures such as minnows, grubs, and maggots, or handcrafted and manufactured jigs, spoons, flies, and decoys. Warm clothing is vital if one is to enjoy, and even survive a wintertime fishing venture.

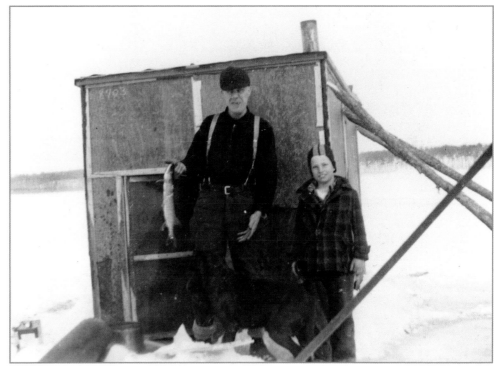

Early fish houses were usually simple structures built with materials at hand. This darkhouse, used for spear fishing around 1935, is small in scale with a tiny duck-through door where grandfather, boy, and dog can smile in the face of winter. Photo from the Runk collection, Minnesota Historical Society.

Although hook and line fishing prevails throughout the Midwest today, spearing through the ice is one of the oldest methods of harvesting fish. Traditional spearing is still practiced by some Native Americans, such as the residents of northern Wisconsin's Lac du Flambeau Ojibwe Reservation. But certainly the best known Midwestern spearing locale is found in the east-central section of the state at Lake Winnebago, where highly regulated numbers of sturgeon are harvested each year. Because a sturgeon can weigh more than one hundred pounds and reach six feet in length, the ice holes in Lake Winnebago are huge, usually four by six feet in dimension. In Minnesota, where the spearing of northern pike is permitted from December through February, close to 15,000 aficionados purchase licenses each year. While game fish such as sturgeon, pike, and walleyes receive the greatest public attention, about ninety percent of the entire wintertime catch consists of panfish, primarily bluegills and perch.

In the not-too-distant past, fishing was undertaken to secure food for human consumption; today, of course, the vast majority of Midwesterners engage in either cold- or warm-weather fishing for recreational reasons. Fishing competitions highlight the winter season, and have become huge events, nowhere more so than in Minnesota, now acknowledged as the nation's "ice-fishing contest capital." The contests date back to the 1930s when St. Paul Winter Carnival organizers started sponsoring fishing competitions on White Bear Lake. By 2003, sixty-eight contests attracted over 90,000 participants to various lakes in Minnesota. The largest is the "Brainerd Ice Fishing Extravaganza," first held on Gull Lake in 1990, and now an event that draws more than 10,000 entrants who competed in 2007 for $150,000 worth of prizes, including a Ford 4x4 truck, a Suzuki ATV, and $10,000 in cash. Another ice-fishing contest, this one dating to 1980, is the "International Eelpout Festival," held on Leech Lake near Walker. The annual occasion mocks the burbot or eelpout (sometimes called a "lawyer" or a "poor-man's lobster"), a snake-like fish that many people view with disgust and even revulsion. Although this contest also attracts close to 10,000 people, it is estimated that only 40 percent of the registrants actually engage in fishing; most come to watch the high jinks and frivolity, as well as the awarding of the grand prize—a $5,000 custom-made eelpout fish house in 2007. Adding humor to Minnesota's early winter scene is Aitkin's "Fish House Parade," which occurs on the Friday immediately after Thanksgiving. The event began in 1991 when local residents celebrated the forthcoming ice-fishing season by "decorating their fish houses up in the most absurd and whackiest fashion," and then parading them down the main street of town.

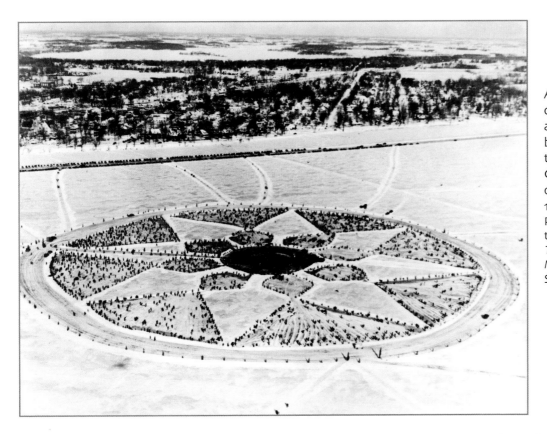

An artistic arrangement of drilled fishing holes and fishing people can be seen from the air at the St. Paul Winter Carnival Fishing Contest on White Bear Lake in 1950.
Photo by Wayne Bell for the *Minneapolis Star Tribune*, collection of the Minnesota Historical Society.

A much smaller number of people view ice fishing in more philosophical terms, such as a few residents of Garrison Keillor's fictional Lake Woebegone who retreat to the solitude of a frozen lake to contemplate the meaning of Schopenhauer, Kirkegaard, and Nietzsche. Lake Woebegone notwithstanding, a more understandable explanation of fish houses and ice fishing "philosophy" is found in the play, *Guys on Ice*, which, following its 1998 premier in Door County, Wisconsin, has been performed yearly throughout the state, had a six-month-long run in the Twin Cities, and has appeared in several other states. *Guys on Ice* features two northern Wisconsin fishing chums, Lloyd and Marvin, who reflect on life, love, and, quite obviously, the elusive one that got away; much time is also spent keeping their precious Leinenkugle beer away from Ernie the Moocher. Employing clever dialogue and lyrics—with song titles such as "Ode to a Snowmobile

Suit," "De Fishing Hole," "Fish is de Miracle Food," "The Guy from Tee Vee," and "Twelve Beers in a Twelve Pack"—Lloyd and Marvin muse about the Green Bay Packers and the women in their lives as they "drink beer, play cards, bait the hook, and give a desultory tug on the line while sorting out life's puzzling events." The play also demonstrates, once again, that ice fishing is not always about catching fish, since the bait at the end of their lines usually fails to attract any bites.

Buildings on Ice: Tipis, Shanties, and Houses

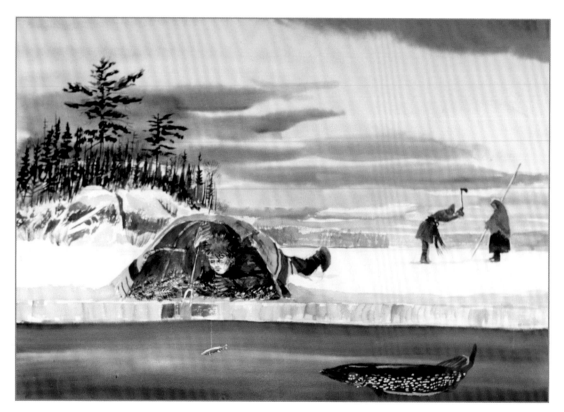

A traditional Ojibwe fishing shelter is pictured in this watercolor by Carl Gawboy.
Image courtesy of Min-no-aya-win Human Services Center.

The earliest descriptions of Midwestern fishing shelters are found in nineteenth-century accounts of Ojibwe "dark houses" on Lake Superior. Some contemporary Ojibwe fishers still build tipi-like structures that utilize both traditional and modern construction materials. After clearing the snow from a circular area that has a diameter of about ten feet, a fishing hole is chipped out of the ice. Four or five small, equally spaced holes are then chopped around the perimeter of the opening, saplings are placed in the holes, the tops are bound with twine, and the ice floor is covered with conifer boughs. The wooden framework is enclosed with quilts and blankets to form an interior covering, and a final layer of canvas and plastic tarpaulins is placed on top to form a windbreak. When completed, the interiors of such shelters are fairly warm and completely dark.

Nineteenth- and early twentieth-century European immigrants brought their own fishing traditions to the Midwest, and also adopted some Native-American practices. Euro-American fishers typically constructed small rectangular shanties with ski-like runners that allowed the buildings to be pulled on and off the ice by horses or humans. One of the primary requirements of ice fishing, then as now, is removing the shelter before the ice melts or becomes too thin to support a building. Numerous factors—the size of the lake, the depth of the water under the ice, the extent of the snow cover on top of the ice, the presence of new ice vs. "rotten" ice—determine if the frozen surface of a water body is solid enough to support a person, a fish house, or the vehicles that now move the shelters on and off the ice. Knowledgeable and experienced ice fishers share in the sport's common wisdom and culture: "good fishing etiquette; numerous stories of great catches or great disasters; knowledge about the fish they strive to catch; and an understanding of the ice itself."

When compared to the past, today's fish houses reveal a much broader range of styles, types, and materials. Still evident are many traditional shanties, often six by eight feet in size, which typically consist of little more than four walls, a door, a roof, a bench, and perhaps a small window and a pipe or vent for a simple heating device. By the late 1980s, however, Larry Stark and Magnus Berglund observed that Minnesota's fish house inventory still had the "refrigerator box, tent or a remodeled camper shell," but also revealed "two-story 16 x 20-foot cabins on runners decked out with fireplace, couch, TV stereo, microwave, carpeting, insulation and Thermopane windows." They described a Mille Lacs Lake fish house, used each winter weekend by two women, as "an attractive place with ivory aluminum siding, a white storm door and a TV antenna on the

roof." One of the women exclaimed that their fish house had "everything," except for "a man and running water."

Even the magazine published by contemporary style maven Martha Stewart has recently discussed fish houses. Verlyn Klinkenborg's 2002 article on Maine's "bob houses" celebrated the vernacular qualities of the buildings, especially their scavenged materials, simple lines, stark exteriors, and interiors displaying "cup-holder ingenuity"—but expressed displeasure with the growing presence of prefabricated structures that lacked charm and "violate[d] the spirit of ice fishing." To Klinkenborg, ice fishing "glories in the words shanty and shack and revels in its self-sufficiency and its cheapness."

Kathryn Nordstrom's images represent a continuum of vernacular fishing shelters, with shacks and shanties at one end, and buildings that are the equivalent of small cabins at the other. Most are on runners or skids. Another highly variable group of shelters includes trailers, some with or without their wheels; a limited number of converted vehicles and truck cabs; a small sample of self-powered conveyances; and even a few structures that emulate space-age forms and materials. Pre-fabricated buildings are also evident; but as in Maine, most do not express the individuality and creativity of their vernacular counterparts, and they have little, if any, local or regional identity and character.

But the face of contemporary Midwestern ice fishing is now changing even more noticeably because of the growing popularity of portable shelters. One can fully understand why many find these units so attractive: they are lightweight; they may be moved quickly and easily to a new fishing spot without a vehicle; and they require no particular skill to erect. Although many fishers—those who wish to overnight on a frozen lake, maintain the heat and warmth of their own residence, or keep several fishing holes under a single roof—will eschew portable shelters, there is no doubt that portables represent a noticeable transition in fish house culture and practices. That is why this book will have long-term value, for in the future people will look back at this period of early twenty-first century ice fishing history and observe an activity that was on the cusp of major changes.

Arnold R. Alanen

Endnotes

Tom Gruenwald, *Modern Methods of Ice Fishing* (Chanhassen, MN: Creative Publishing International, 1999), 6-7; Al Lindner, Doug Stange & Dave Genz, *Ice Fishing Secrets*, 4th printing (Brainerd, MN: In-Fisherman, 1999), 11-20; *Minnesota Monthly*, "Outdoor Adventure Guide" (February 2007); information about the number of fish house permits in 2006 is from the Minnesota DNR License Center.

"Harvesting Wisconsin Waters: Native-American Fishing Traditions," explanatory text for an exhibition at the Wisconsin Historical Society Museum, Madison, 1997; Ruth Olson, "A Good Way to Pass the Winter: Sturgeon Spearing in Wisconsin." In *Wisconsin Folklore: A Celebration of Wisconsin Traditions* (Madison: Wisconsin Academy of Sciences, Arts and Letters, 1998), 58-61; Dennis Anderson, "Peering, Spearing," *Star Tribune* [Minneapolis], January 28, 2007; Walter Downs, *Ice Fishing* (Madison: University of Wisconsin Sea Grant Institute, 2005), 11.

Jason Abraham, "Minnesota is Becoming an Ice-Fishing Contest Capital," *Minnesota Conservation Volunteer* (January-February 2005); www.brainerdjaycees.com (2007); www.poutfest.com/index.html (2007); *Aitkin Independent Age* [Aitkin, MN], November 22, 2006.

The observations about *Guys on Ice* (lyrics by Fred Alley, music by James Kaplan) are based on my attendance at a December 2005 performance of the play in Madison; and a review by Roberta Kent in the *Ashland Daily Tidings* [Ashland, OR], February 10, 2007.

James P. Leary, "Alex Maulson, Winter Spearer." In *Wisconsin Folklore*, J.P Leary, ed. (Madison: University of Wisconsin Press, 1998), 396-406.

Downs, *Ice Fishing*, 17: Ruth Olson, "Recreational Folklore." In R. Sisson, C. Zacher, & A. Cayton, eds. *The American Midwest: An Interpretive Encyclopedia* (Bloomington: Indiana University Press, 2007), 418.

Larry Stark & Magnus Berglund, *Hook, Line and Shelter: Ice Fishing Tales and Photos, too* (Cambridge, MN: Adventure Publications, Inc., 1990), 7 & 45.

Verlyn Klinkenborg, "Ice Fishing," *Martha Stewart Living* (February 2002), 158-63, quotations on 162.

An avid fisherman while growing up in rural Aitkin County, Minnesota, Arnold Alanen's wintertime angling escapades occurred on Big Sandy Lake with his Finnish immigrant grandfather, who had a preference for whitefish or tullibee. After making his way to the University of Minnesota and securing a BA in architectural studies and a Ph.D. in geography, Alanen joined the faculty in the Department of Landscape Architecture at the University of Wisconsin-Madison, where he specializes in landscape history and historic preservation. Among his numerous publications, many focusing on the Lake Superior region, are the books, *Preserving Cultural Landscapes in America* (2000); and *Morgan Park: Duluth, U.S. Steel and the Forging of a Model Company Town* (2007).

A consultant to the National Park Service on projects from Michigan to Alaska, Arnold Alanen is pictured in cold-water gear just before leaving on a Lake Superior research trip to Wisconsin's Apostle Islands National Lakeshore.

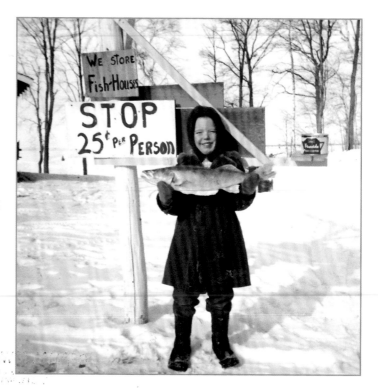

Eddy Lyback proudly displays his catch at his parents' resort in 1962. Twenty-five cents was the going rate to use the ice access road. Eddy is still in the family business and runs a thriving winter fishing operation on Mille Lacs.
Photo courtesy of Phyllis Lyback.

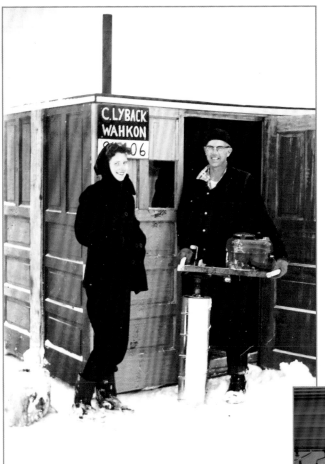

Phyllis and Clark Lyback started one of the first ice fishing businesses on Mille Lacs Lake. Clark is pictured here around 1952 with a neighbor in front of the "Door House." The house was completely constructed of old wooden doors. Clark is holding an inventive handmade ice auger powered by a motor that was interchangeable with their garden tractor.
Photo courtesy of Phyllis Lyback.

In 1946, StrikeMaster Corporation introduced the Swedish Mora hand auger to North America. The company began producing gas and 12 volt power augers in 1976 and has grown to be one of the major auger manufacturers. At the company headquarters in Big Lake, Minnesota, they have assembled an in-house "museum" documenting the history of ice augers. Pictured are augers from the 1960s through the 1980s.

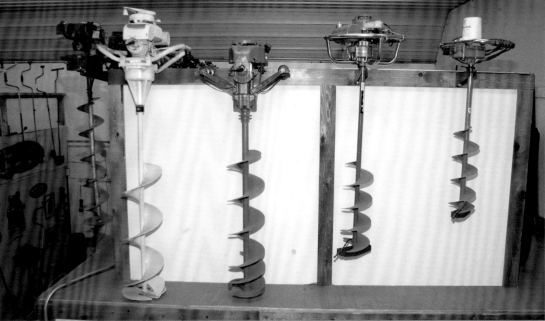

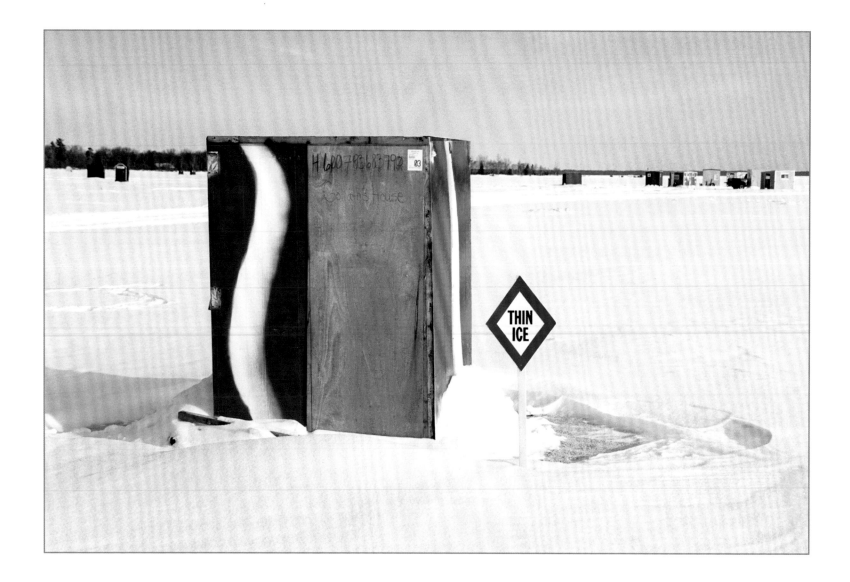

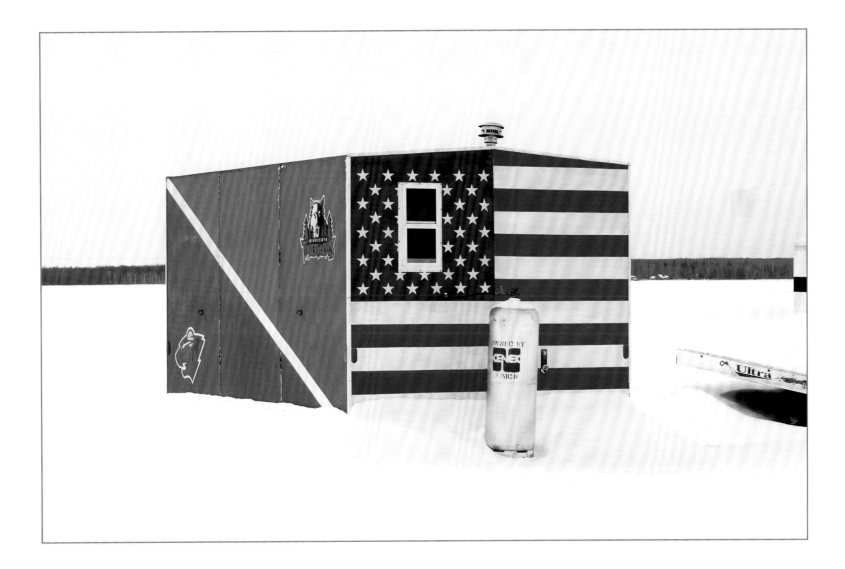

Aitkin Fish House Parade

The ice fishing season is kicked off with great northland style in Aitkin, Minnesota. The annual Fish House Parade greets winter at 1 p.m. sharp on the Friday after Thanksgiving as wildly decorated fish houses and marching groups make their way down main street to the delight of thousands of spectators. This wacky event has attracted the attention of such national media as USA Today, A & E, HGTV, and Comedy Central. The parade is a humorous and fitting beginning of a season on ice.

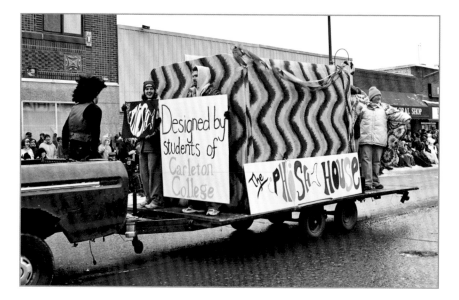

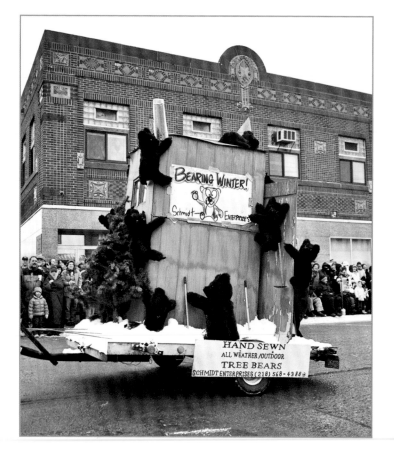

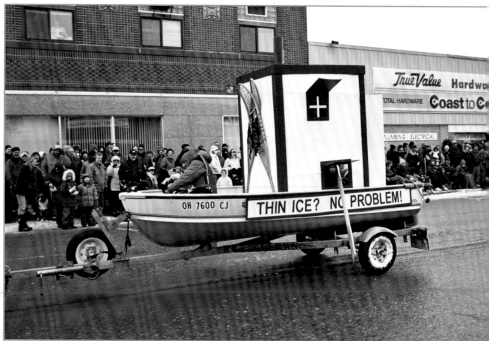

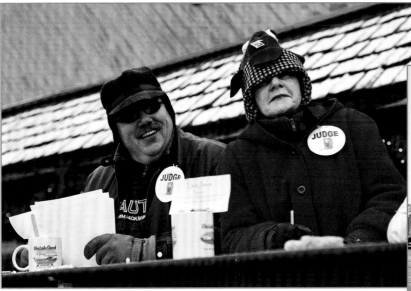

Judges willingly accept and encourage bribes from parade participants.

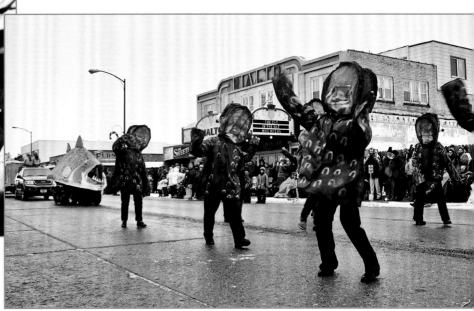

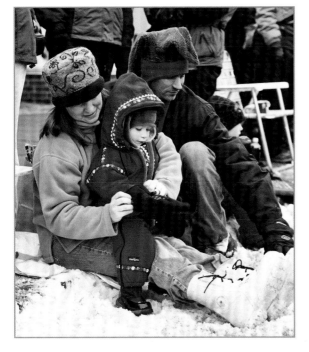

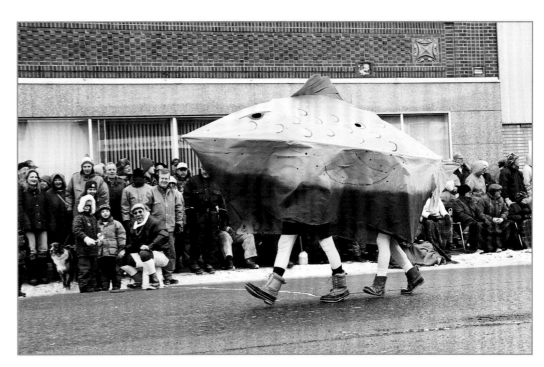

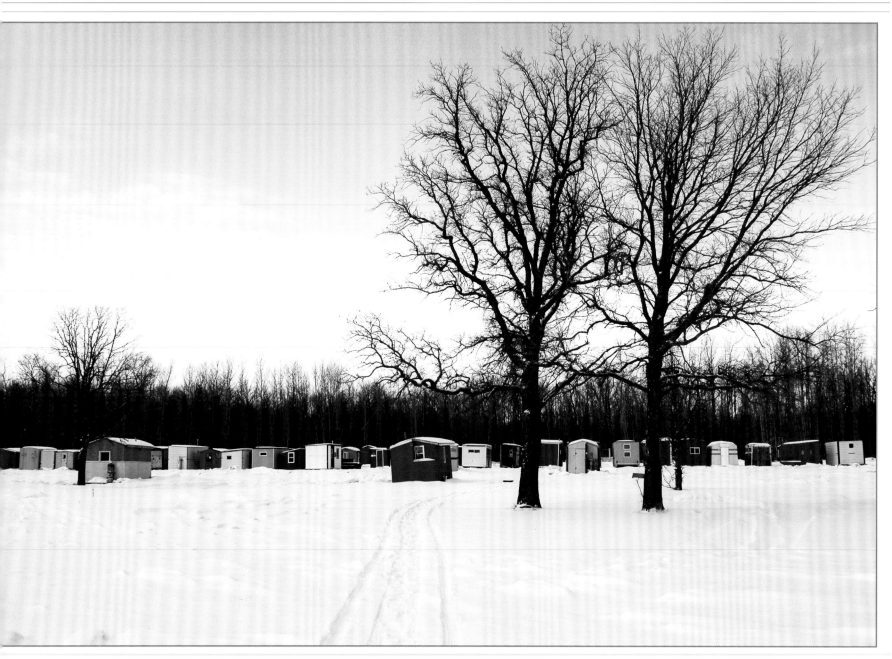

Fish houses are staged on the lakeshore before being towed onto the ice.

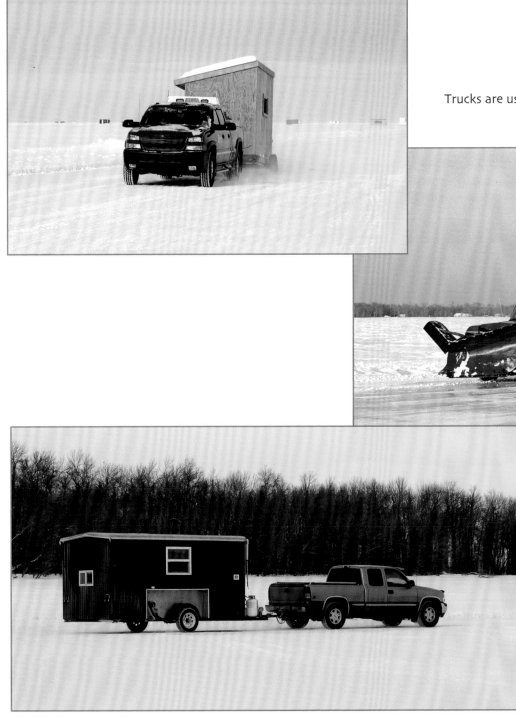

Trucks are used to tow houses on and off the ice.

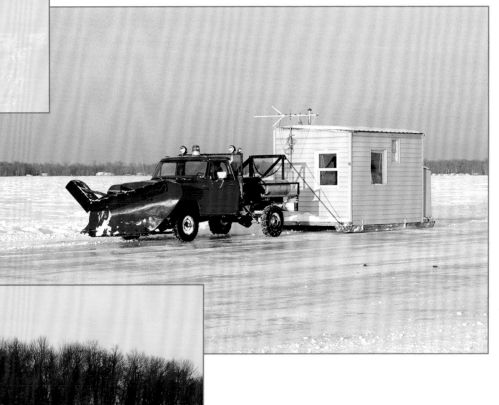

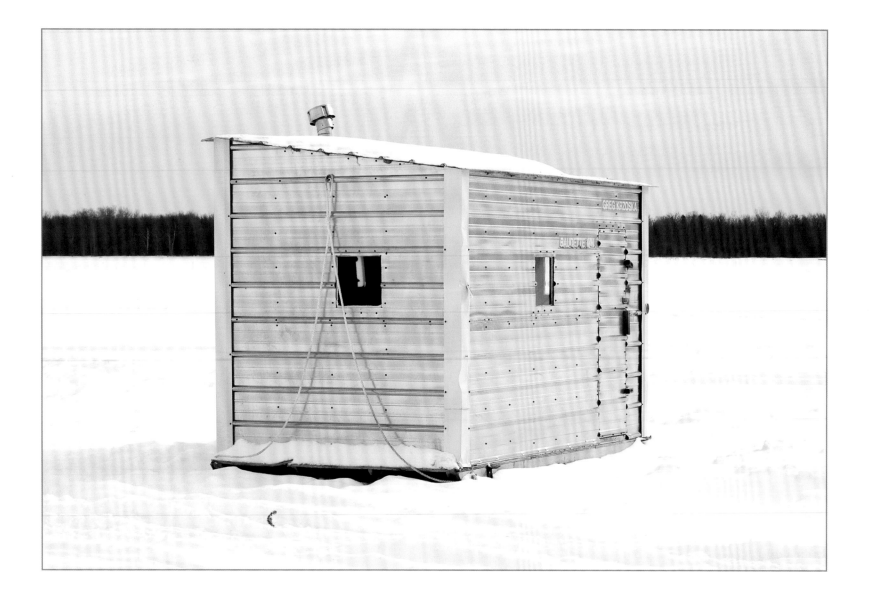

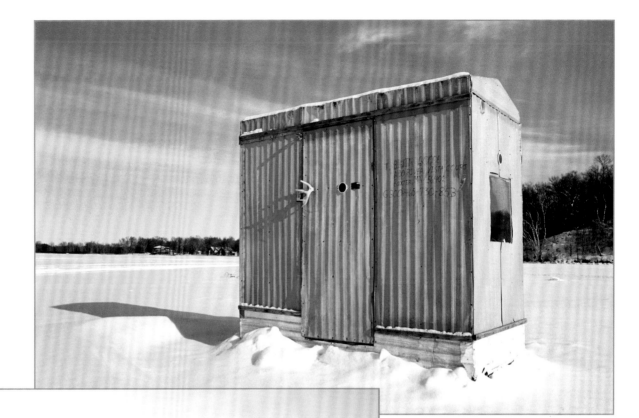

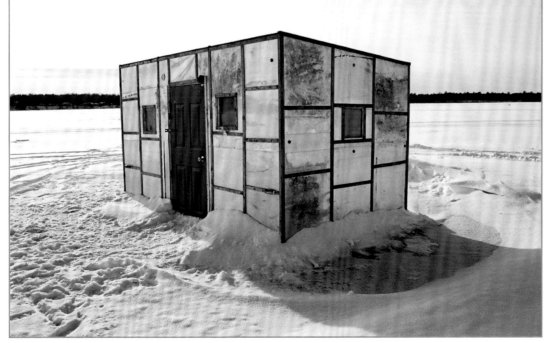

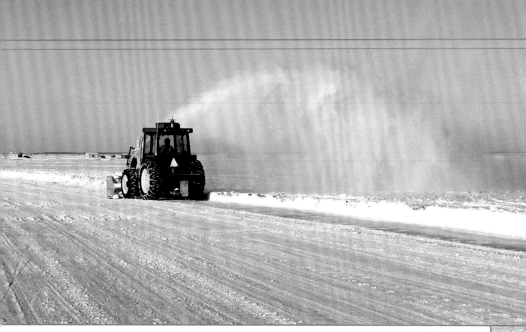

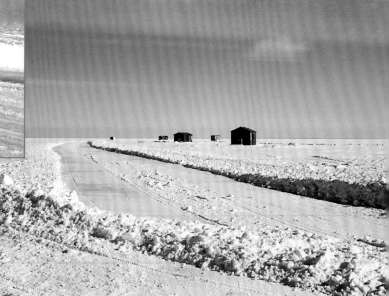

Because fish houses are often located at great distances from shore, roads are needed to provide access to them. Individuals and resorts plow ice roads, complete with road signs, on the lakes. Maintenance is onging to keep roads open and safe. Resorts often charge towing and road usage fees and/or private house storage and service fees.

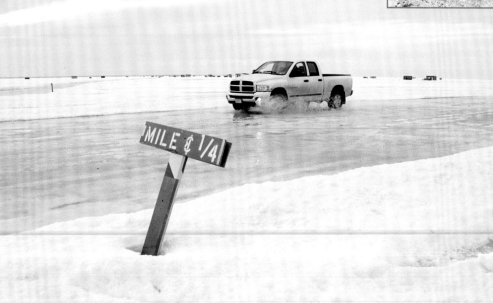

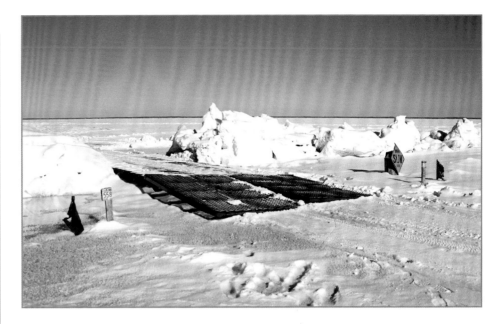

Ice on large lakes will develop cracks from repeated surface heating and cooling. Similar to plate tectonics, long pressure ridges of ice are created and may block roads. Bridges are then built to reach the houses.

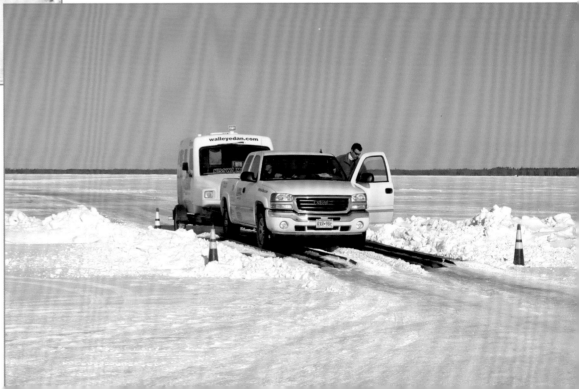

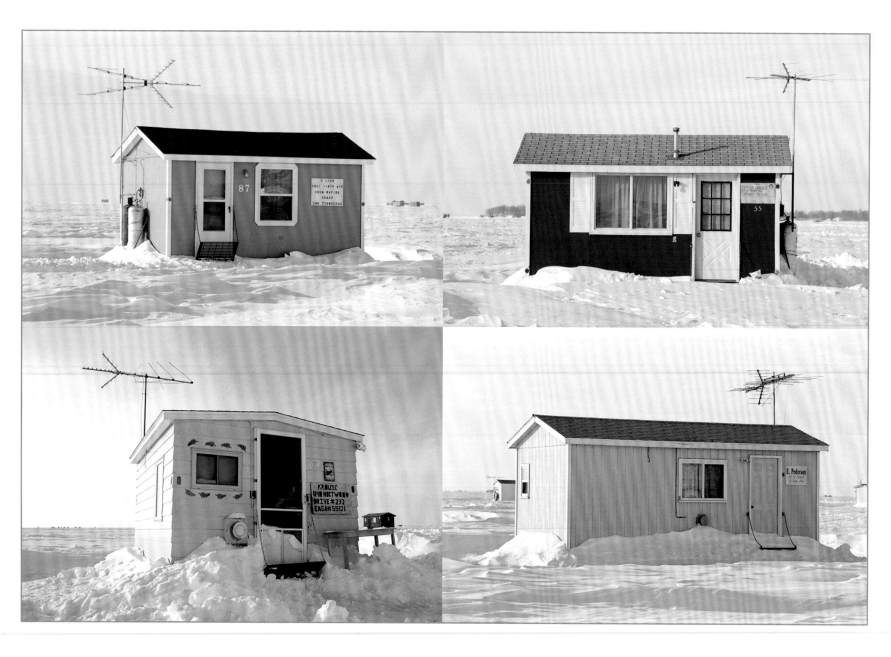

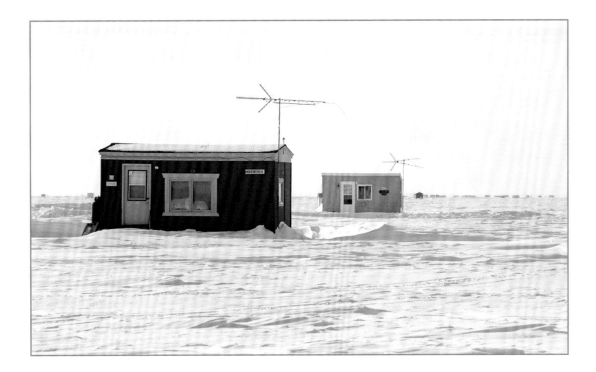

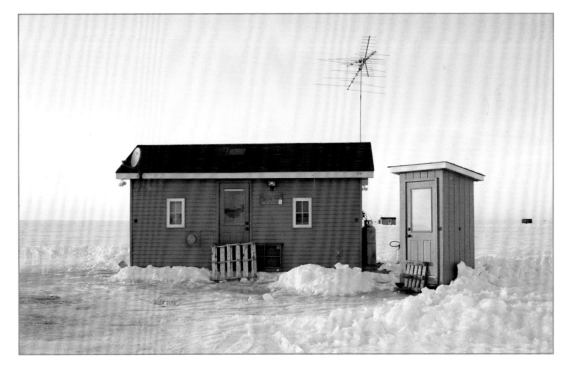

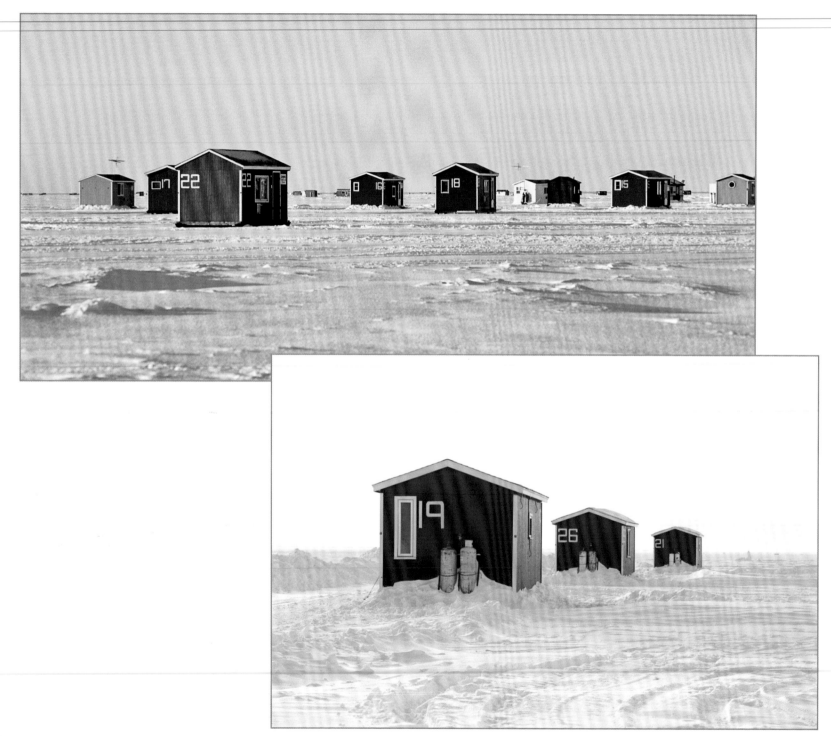

Many resorts operate year-round and are a driving force for keeping lake access open for fish houses and promoting fishing. They offer house rentals by the day for those without their own house, and also for vacationers or anglers who want to try fishing different lakes. Resorts are also great sources for information on current ice conditions and the latest fishing reports.

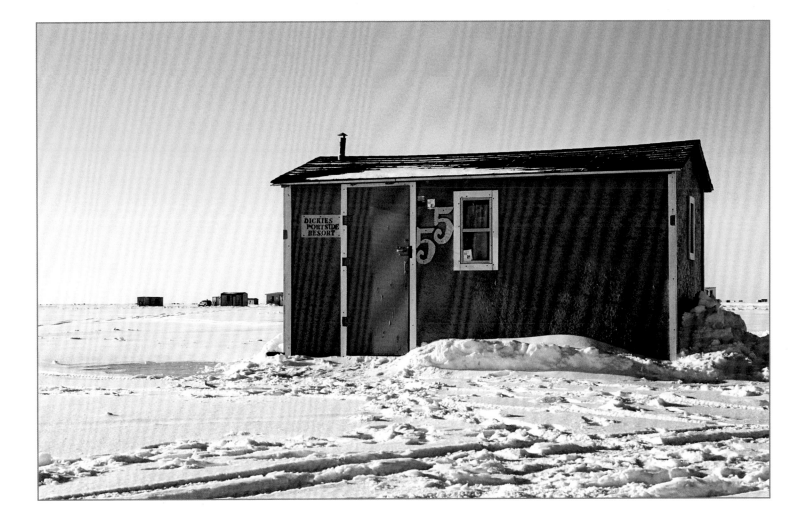

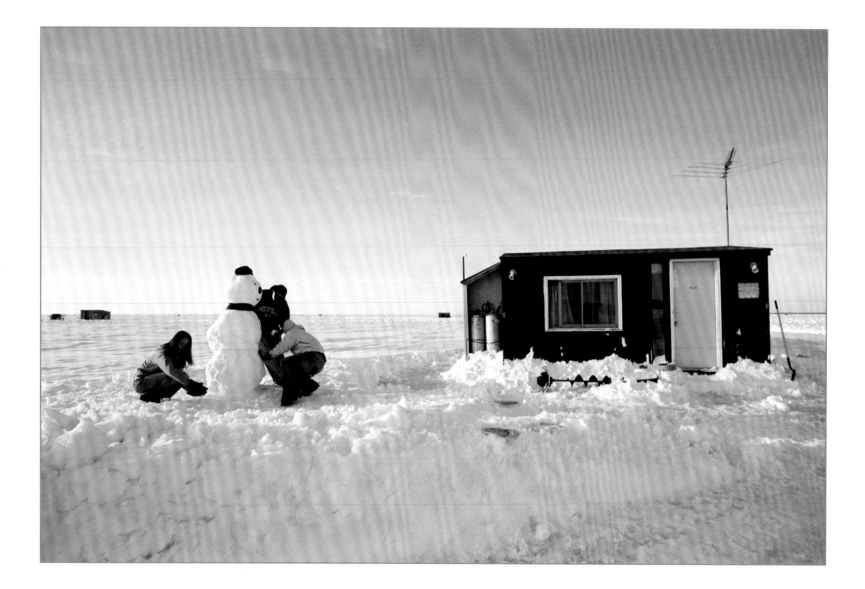

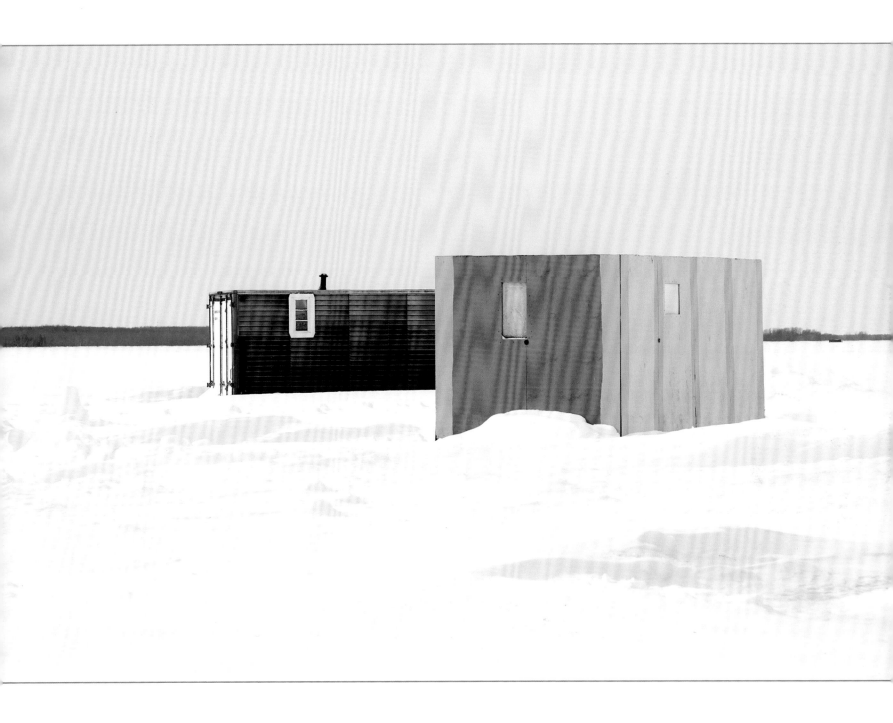

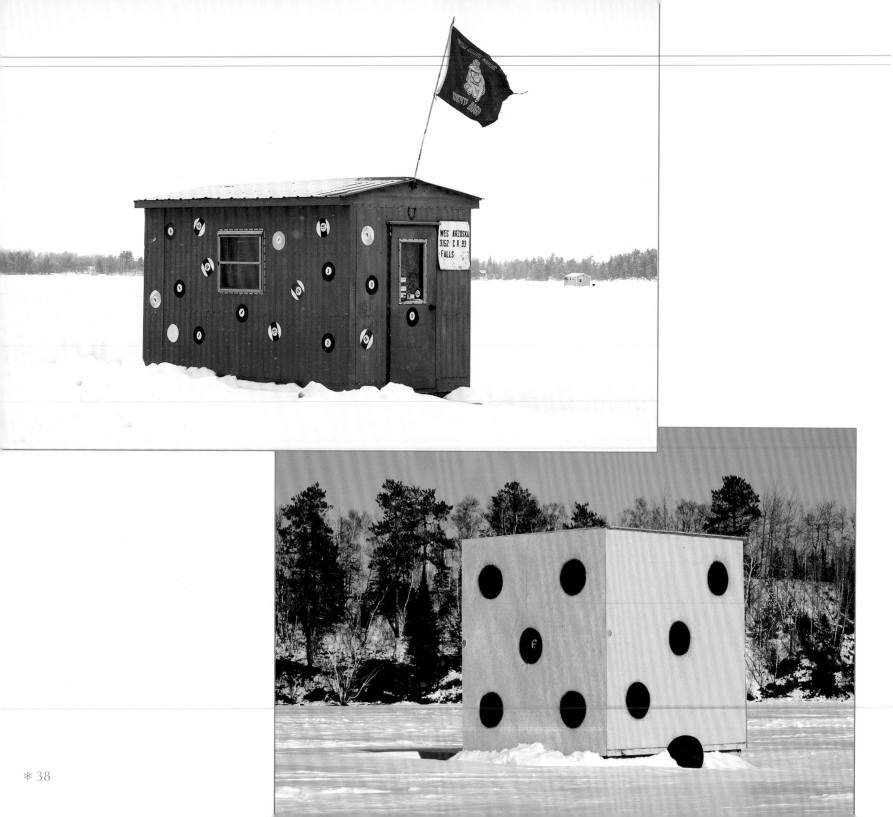

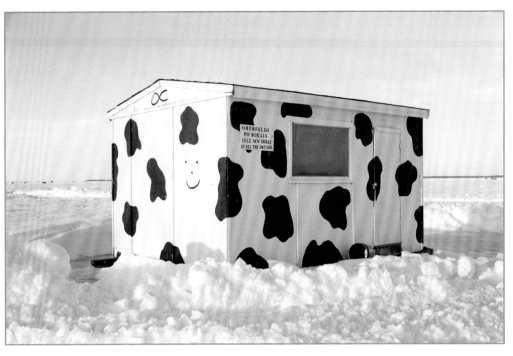

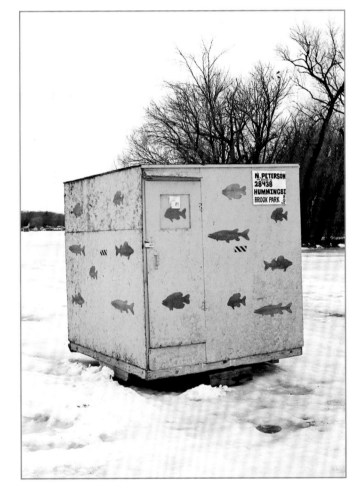

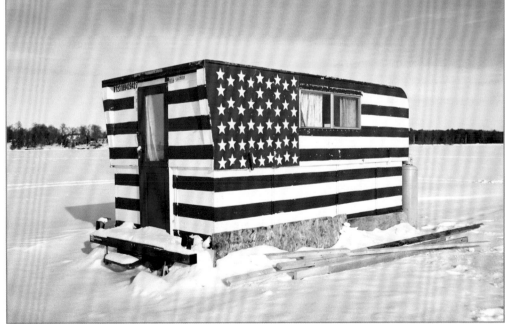

39*

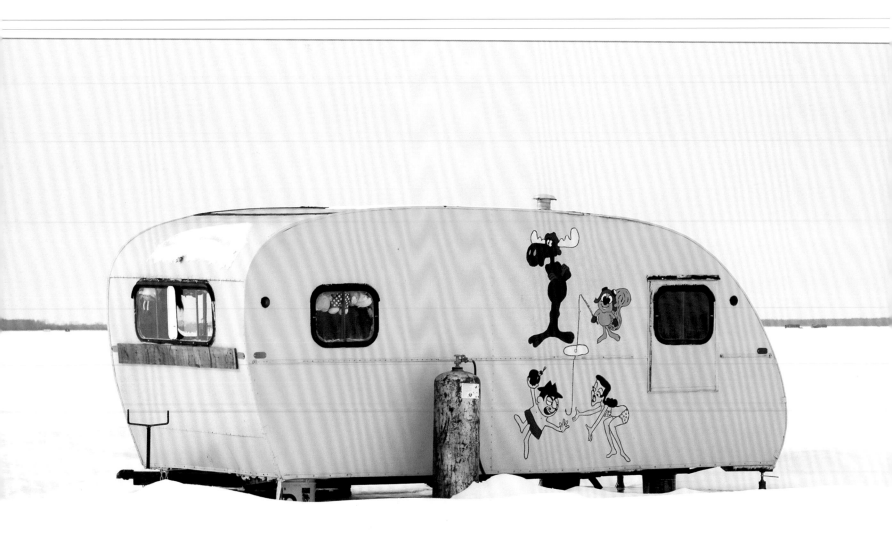

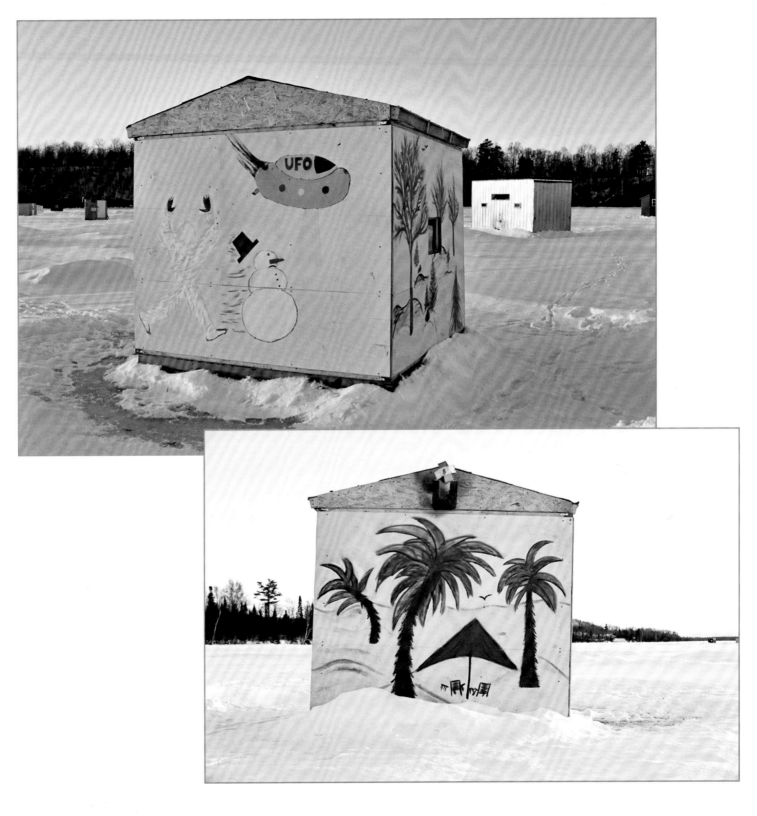

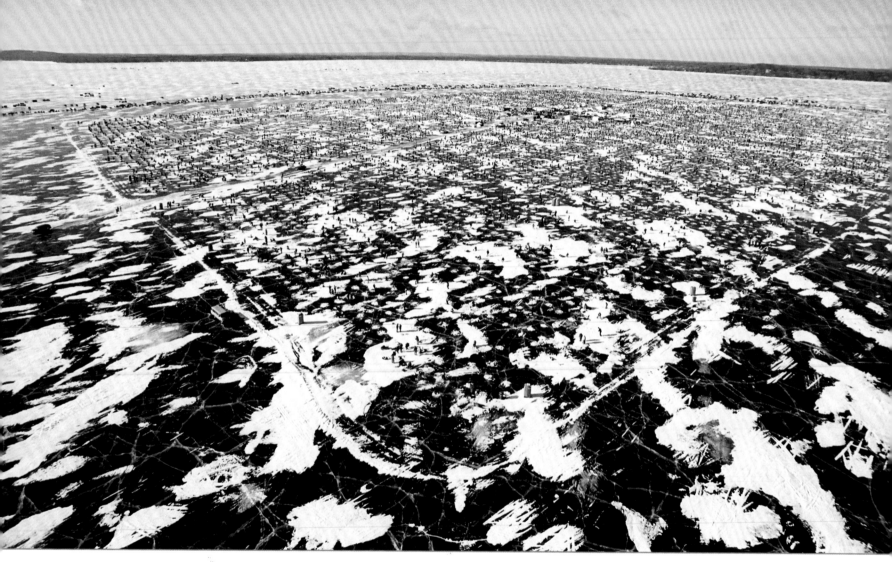

Helicopter view of the contest on Gull Lake.

Annual Brainerd Jaycees $150,000 Ice Fishing Extravaganza

The world's largest ice fishing contest attracts anglers and media from around the world and gives 100% of their proceeds to charity. Volunteers work year-round to prepare for the over 10,000 contestants vying for 150 prizes that have included a truck, $10,000 cash, a custom fish house, and an ATV. Fishing is intense from noon until three when a cannon signals the end of competition. This contest is truly an amazing experience where you can have fun, help a good cause, and maybe drive a new truck home.

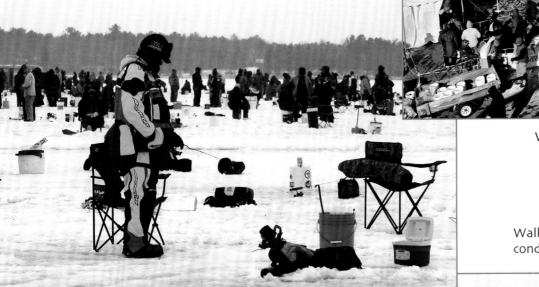

Weigh in line.

Walking in to the Extravaganza on Round Lake. Poor ice conditions forced a switch from Gull Lake in 2006.

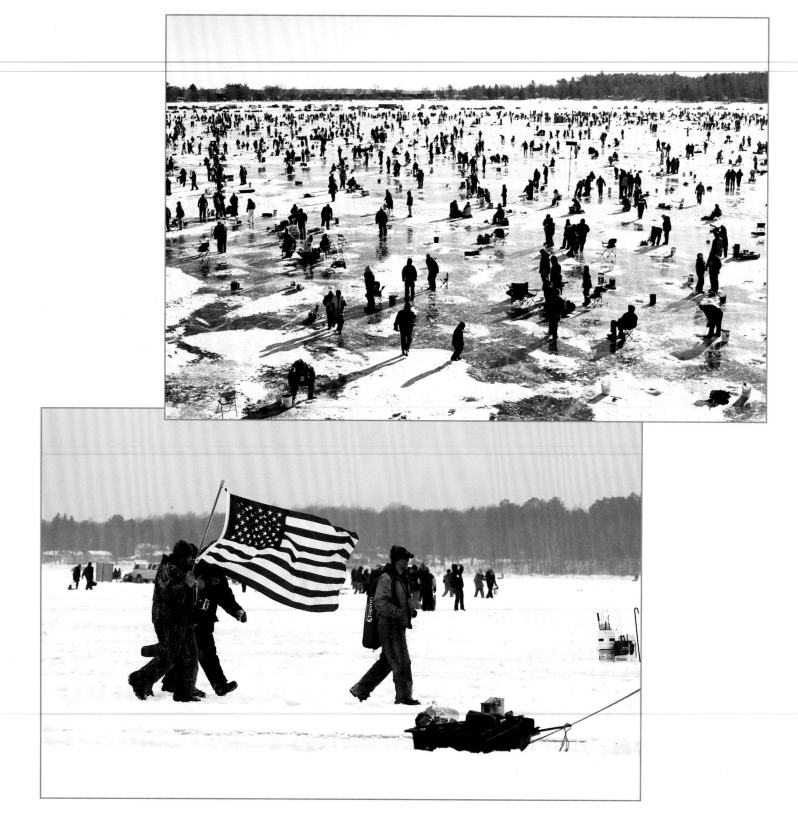

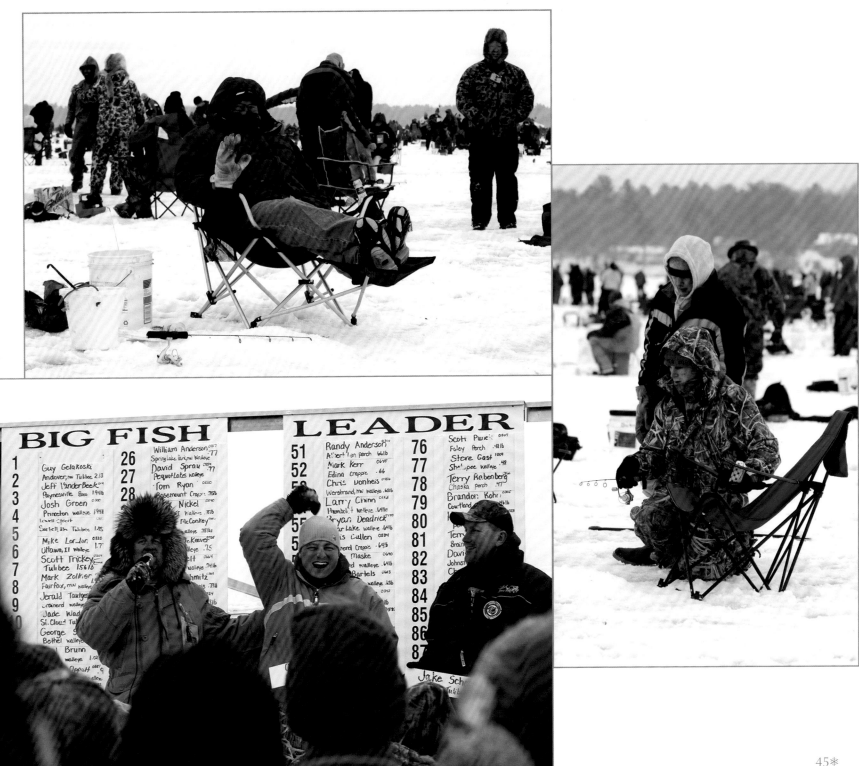

BIG FISH LEADER

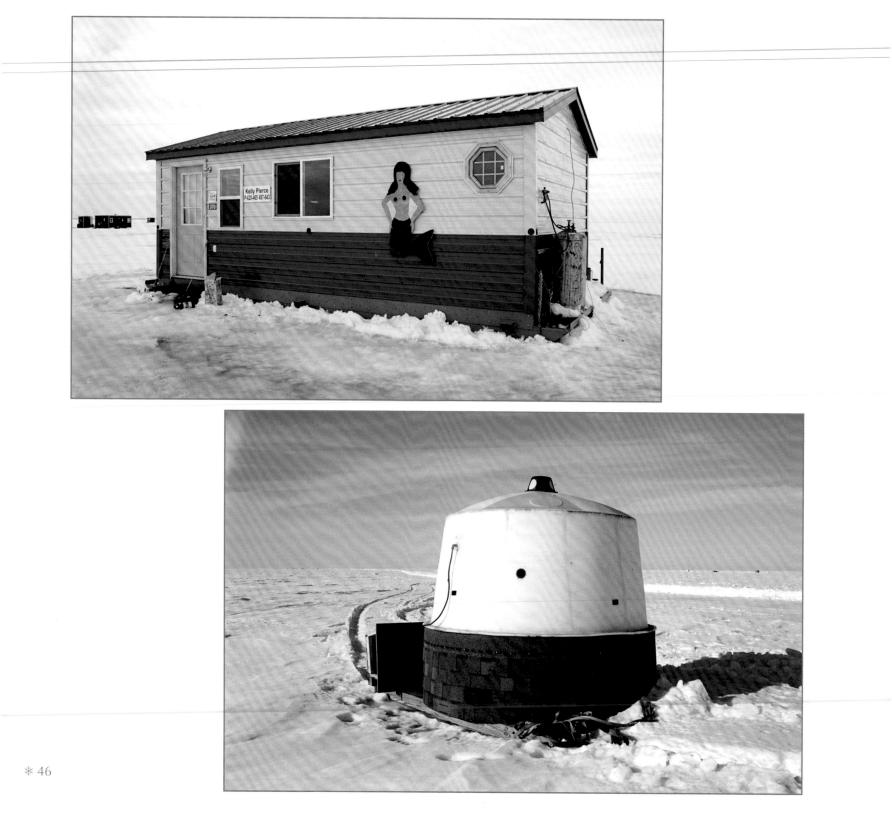

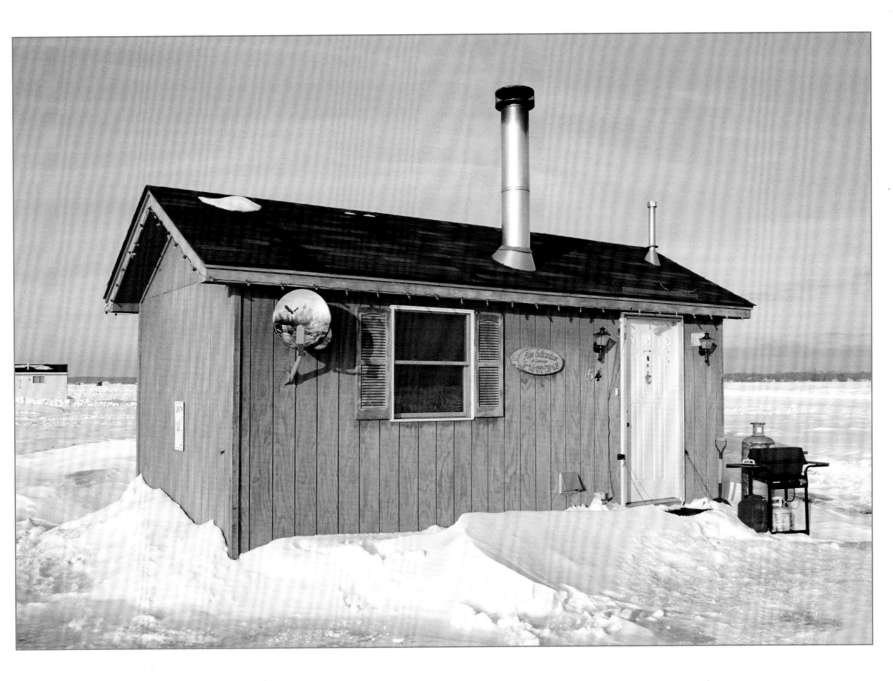

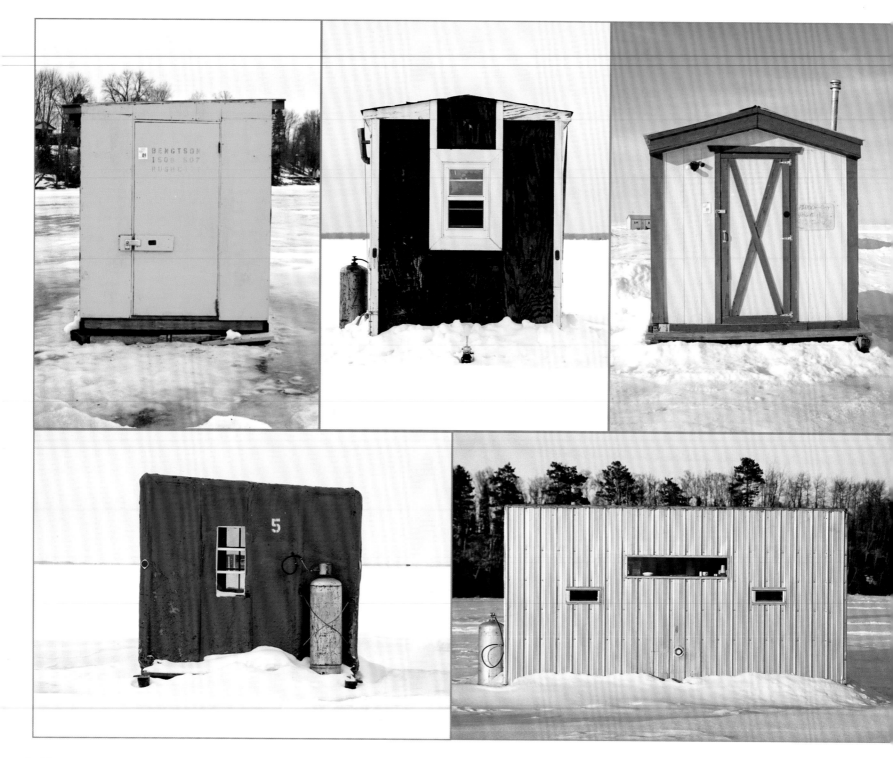

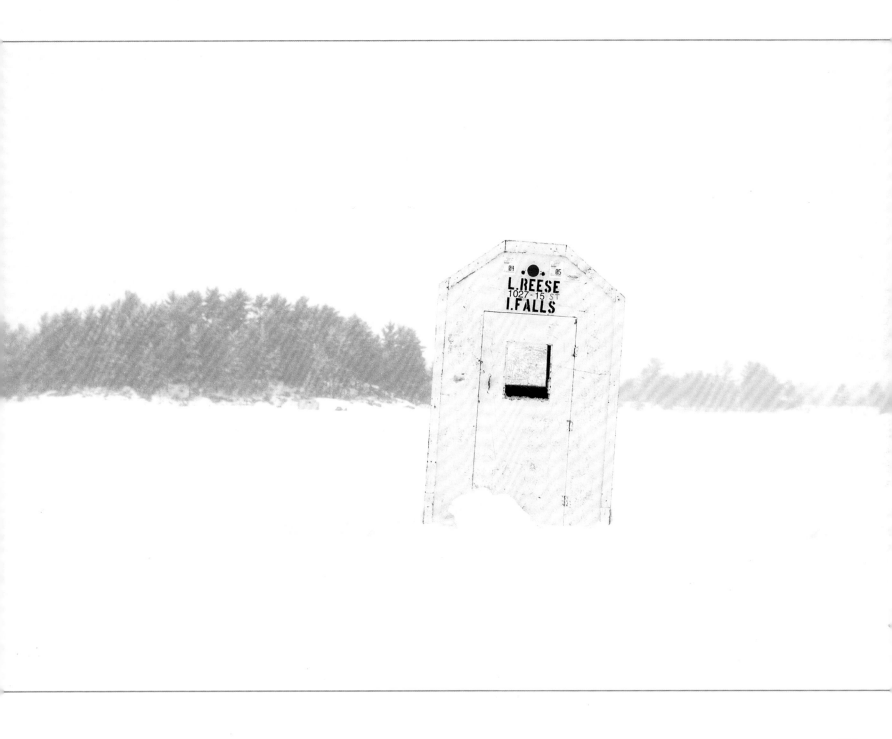

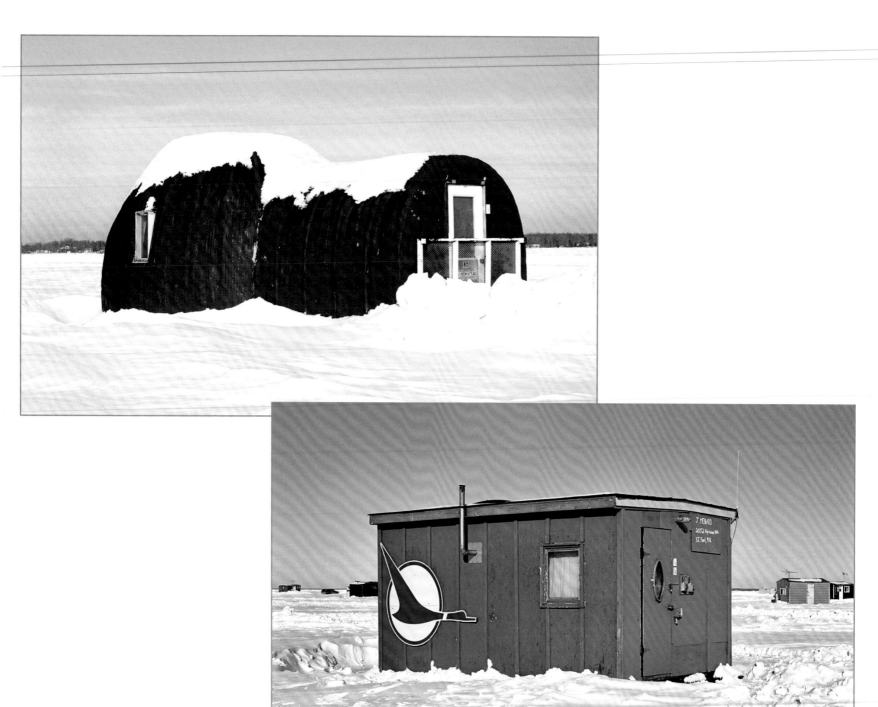

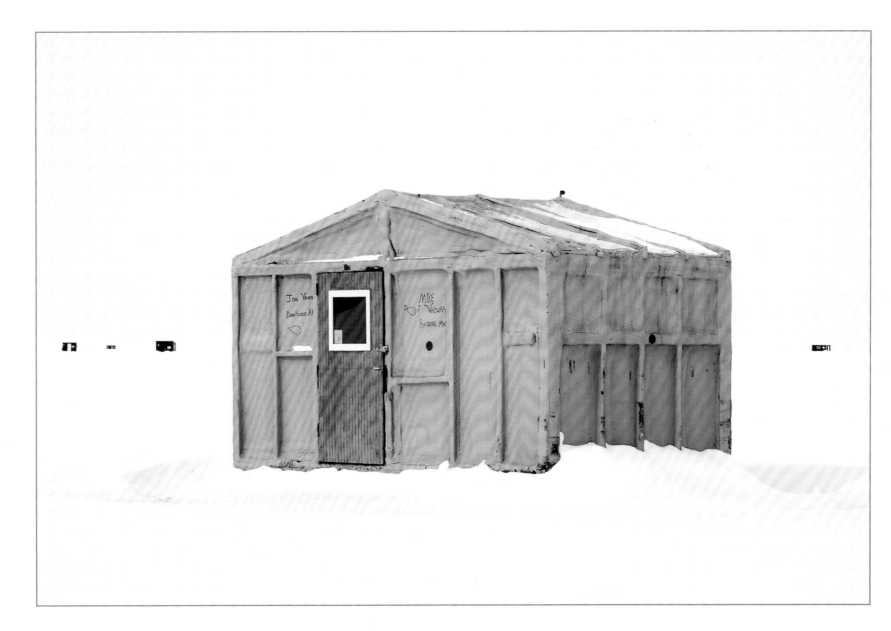

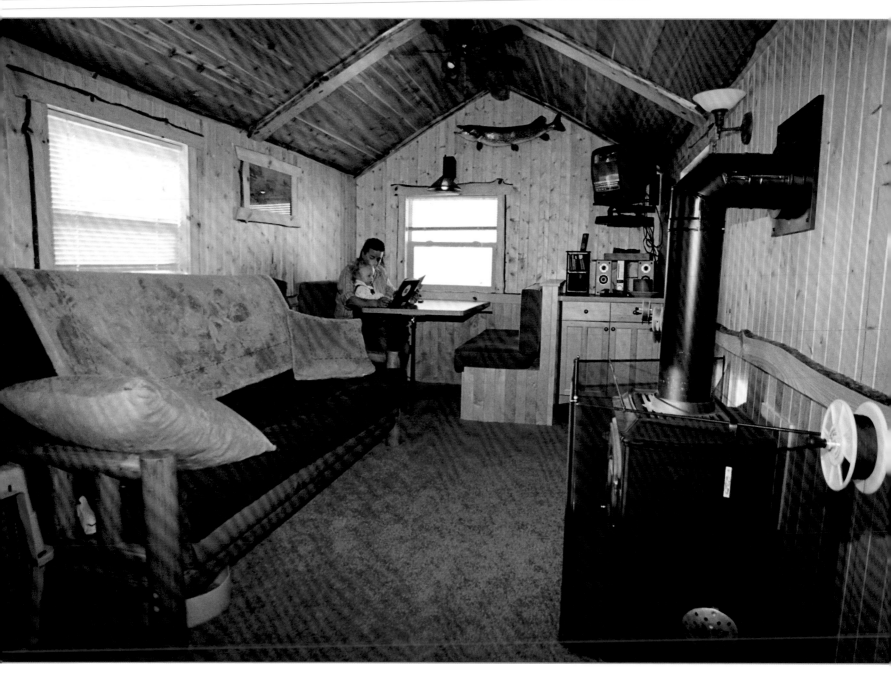

Family time on Lake Mille Lacs.

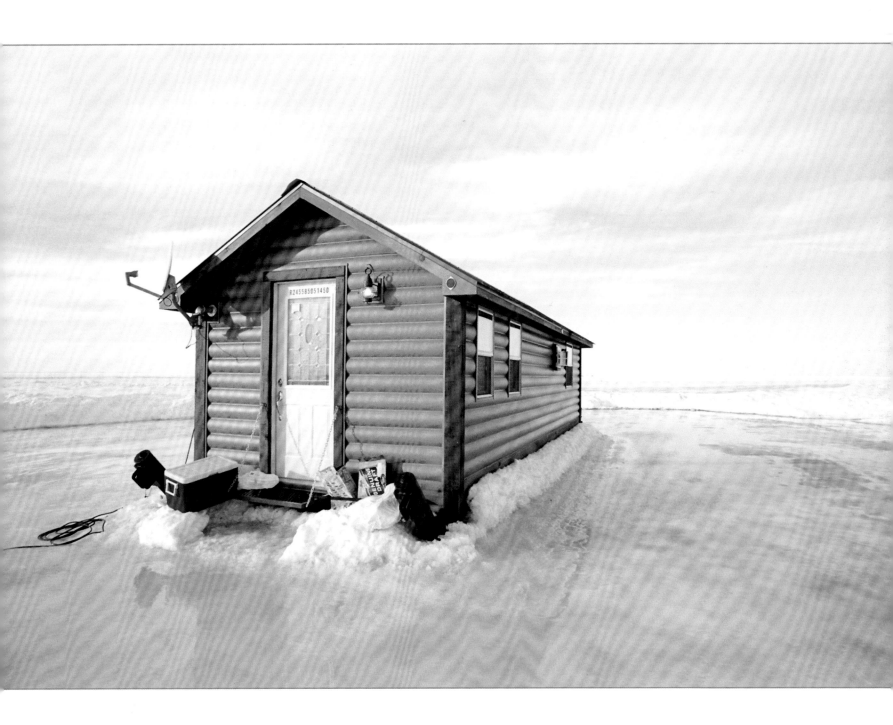

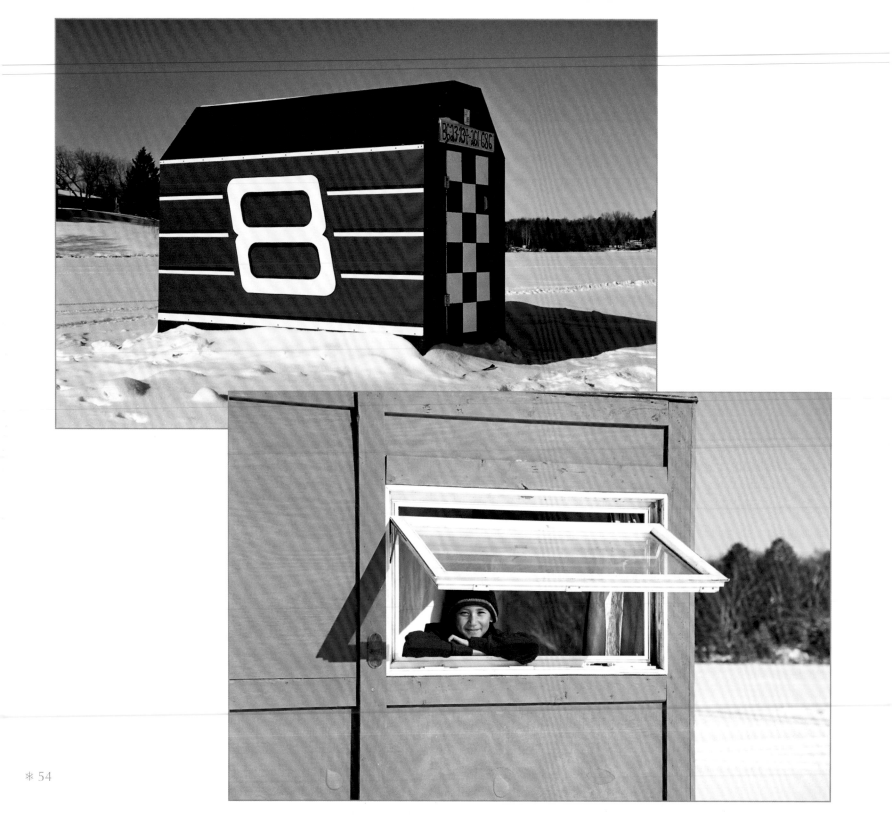

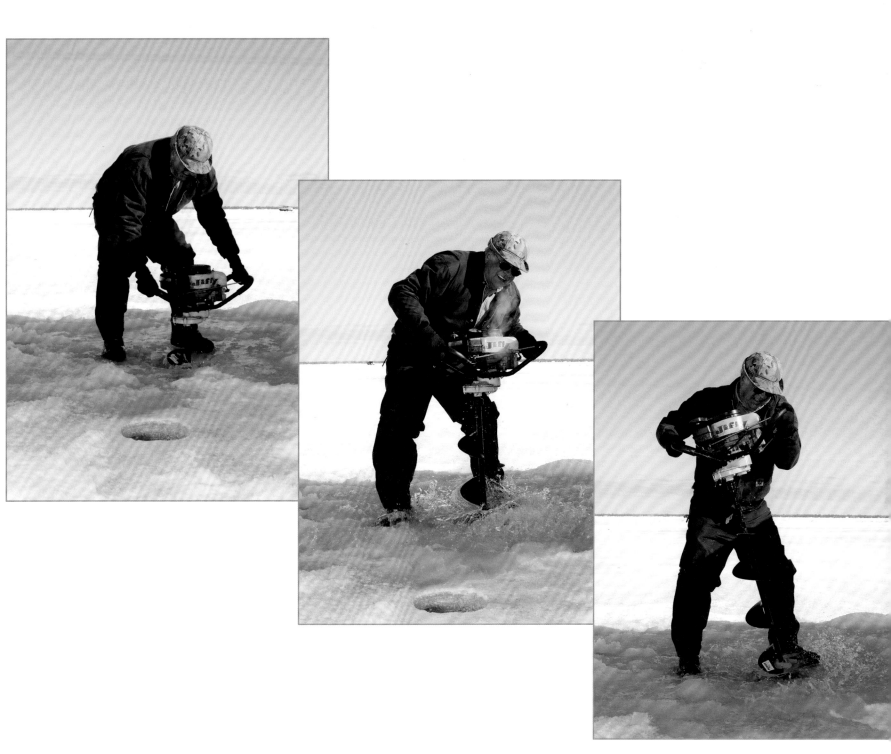

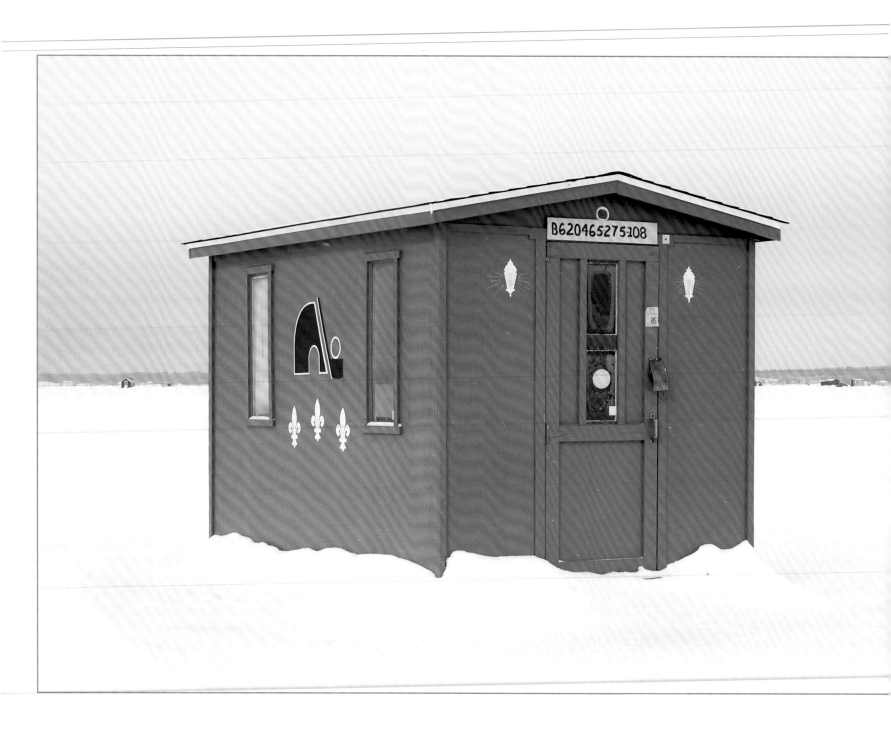

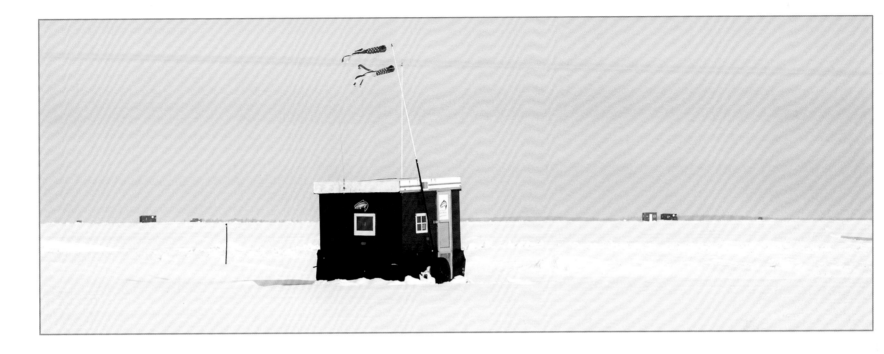

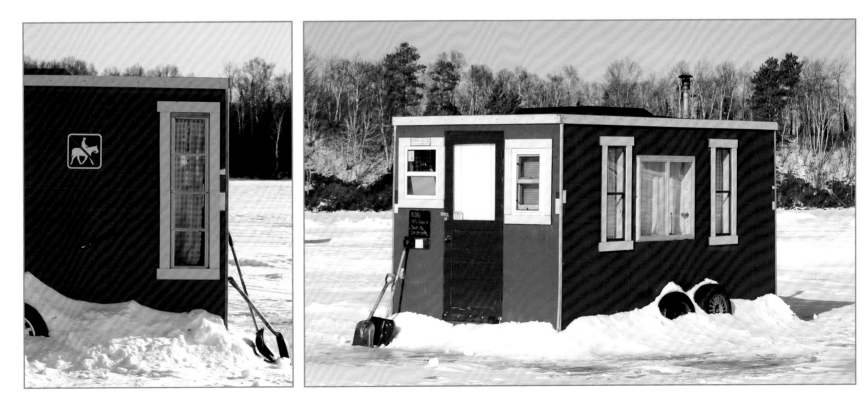

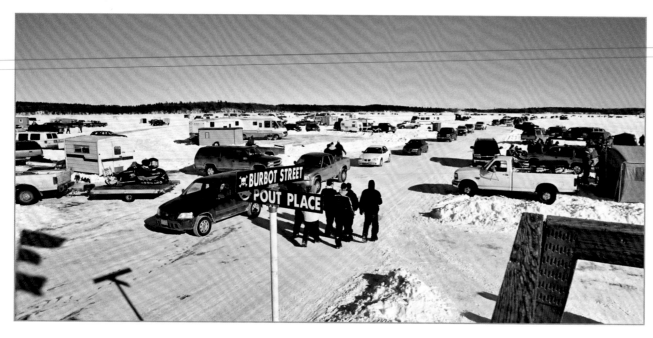

Spectators stream through the encampments.

International Eelpout Festival

The International Eelpout Festival is held annually on Leech Lake in Walker, Minnesota. This unique contest allows fish houses, is all about fun, and features the slimy eelpout. Begun in 1979 by Ken Bresly, this three-day event attracts people from all over the world. Anglers compete for top single pout, tonnage, best encampment, and participate in events such as the Polar Plunge and the Eelpout 500 "On Ice" Auto Race. And you never know what else you might see at Minnesota's Mardi Gras on ice.

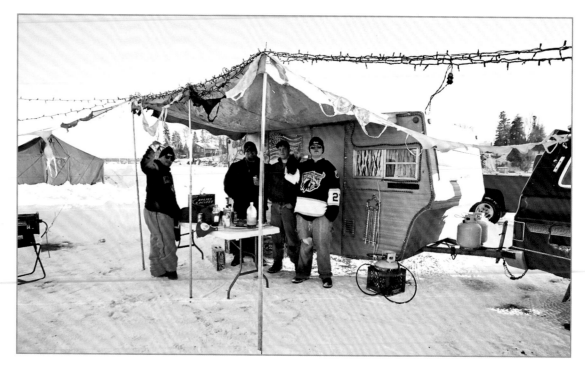

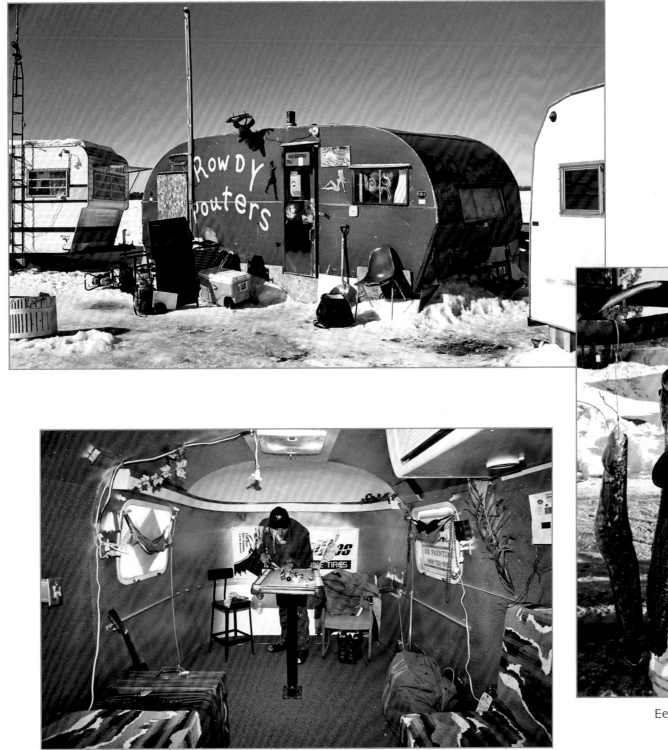

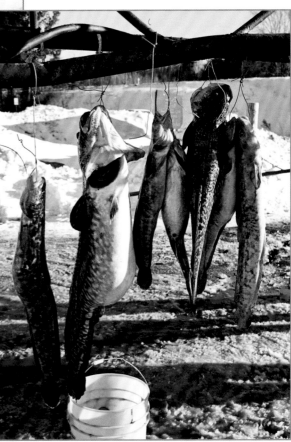

Eelpout after weigh-in.

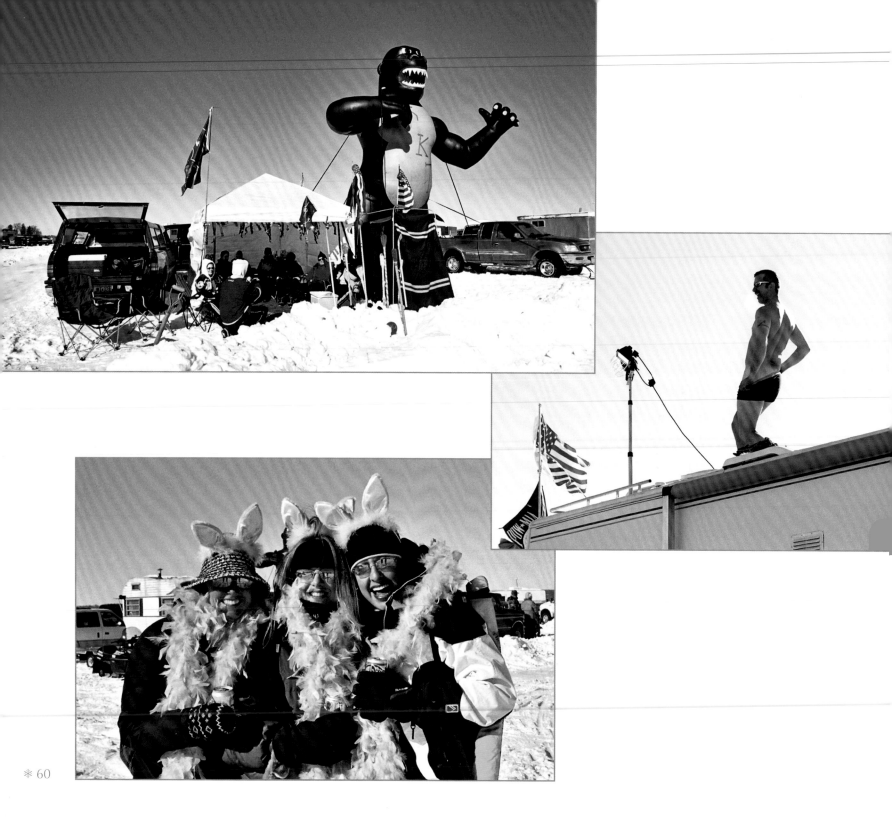

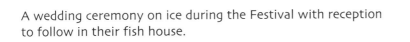

A wedding ceremony on ice during the Festival with reception to follow in their fish house.

Wedding vows were made in Sorels with friends and black lab in attendance.

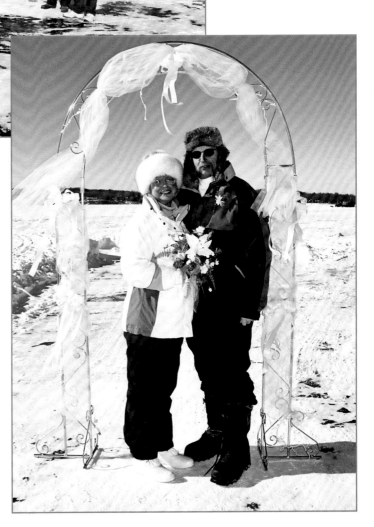

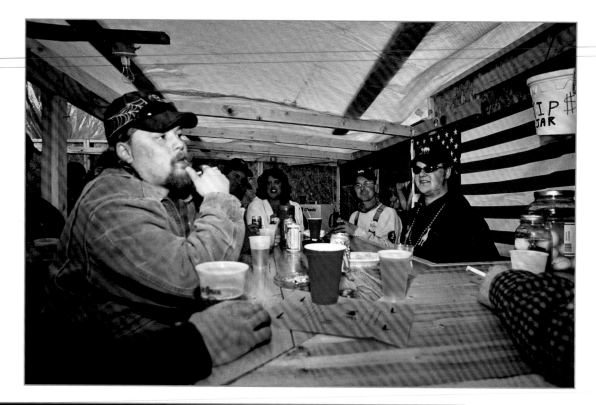

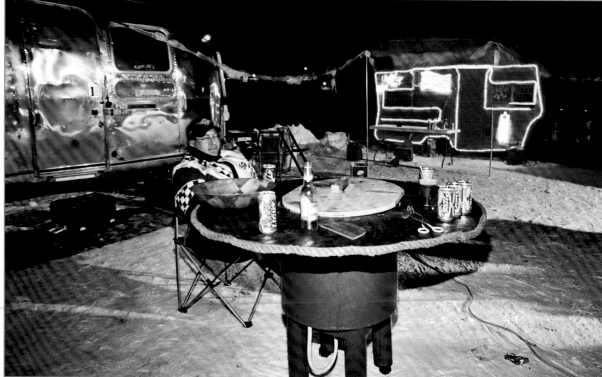

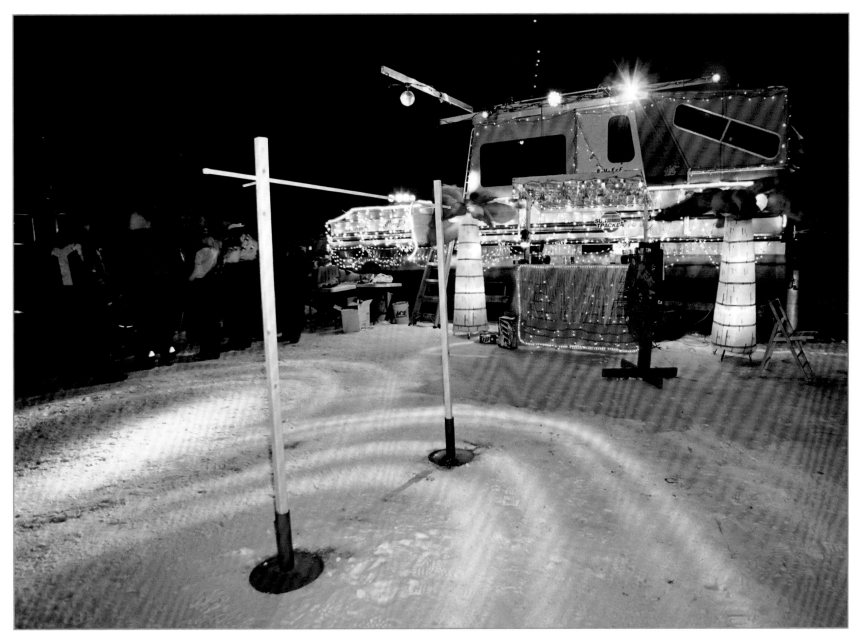

Partying under the lights at Eelpout.

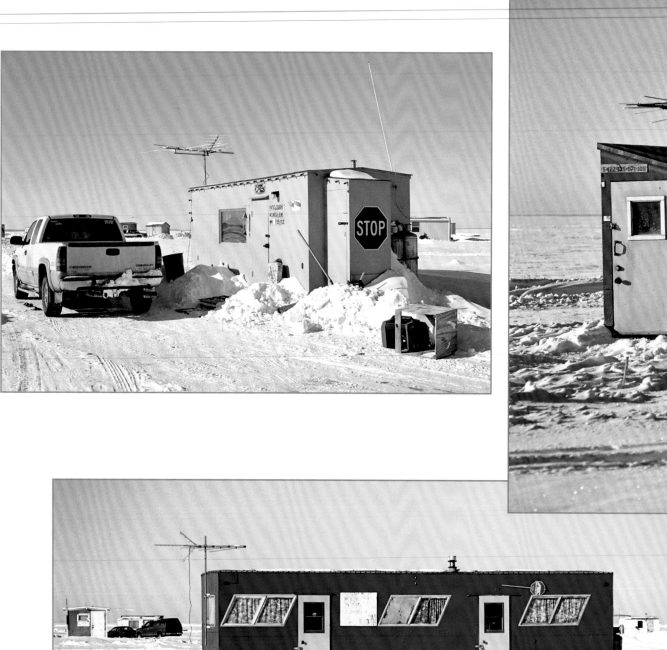

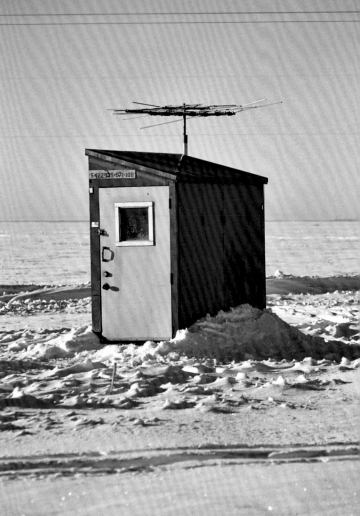

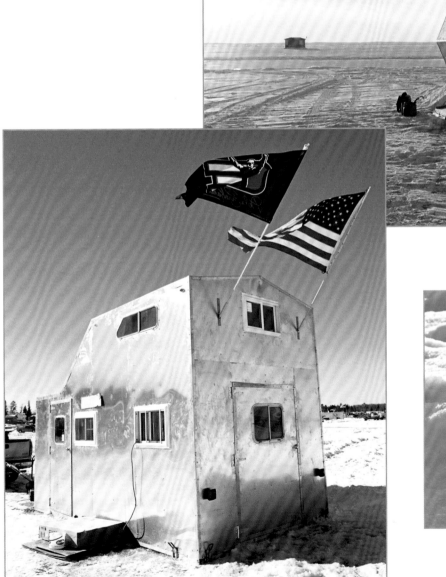

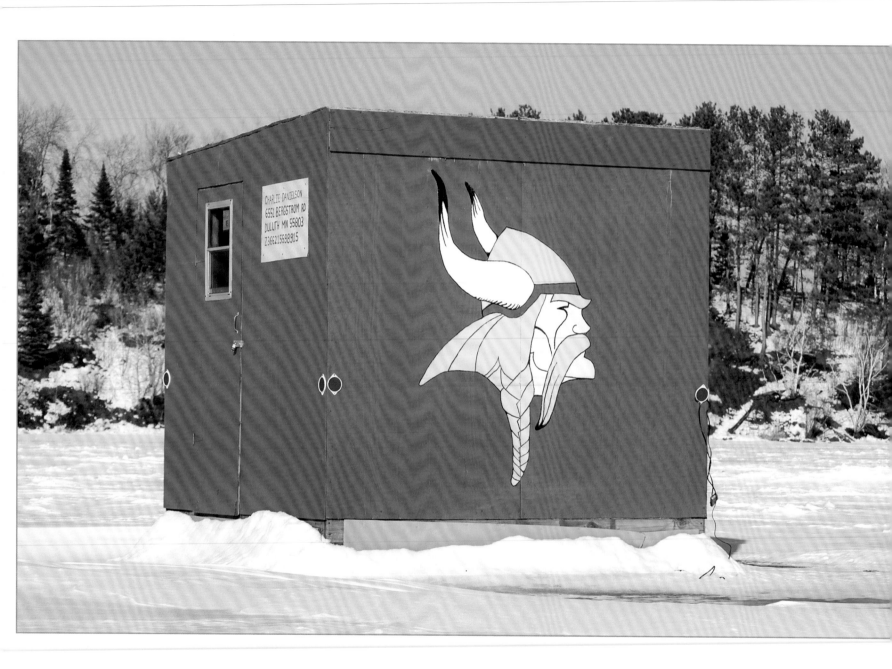

CHARLIE DANIELSON / 6551 BERGSTROM RD / DULUTH MN 55803 / Z366215588915

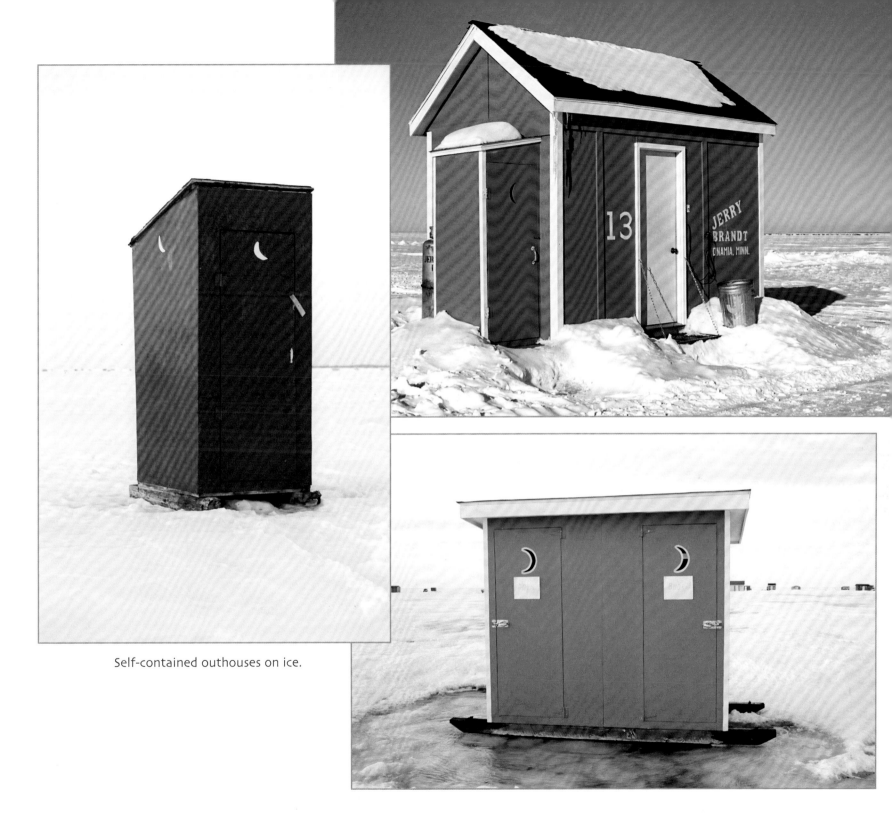

Self-contained outhouses on ice.

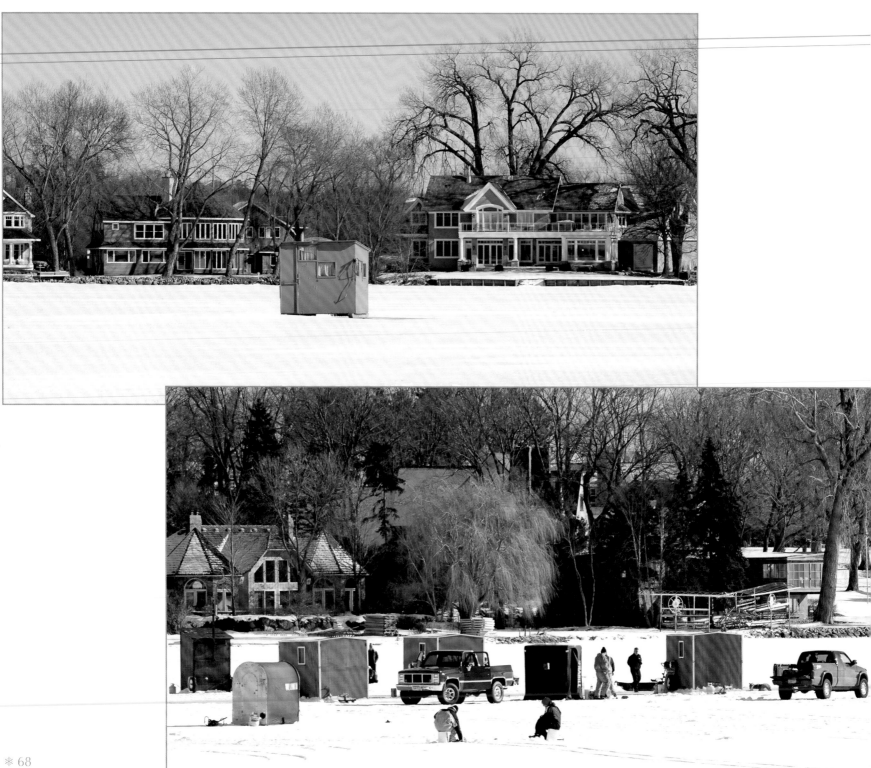

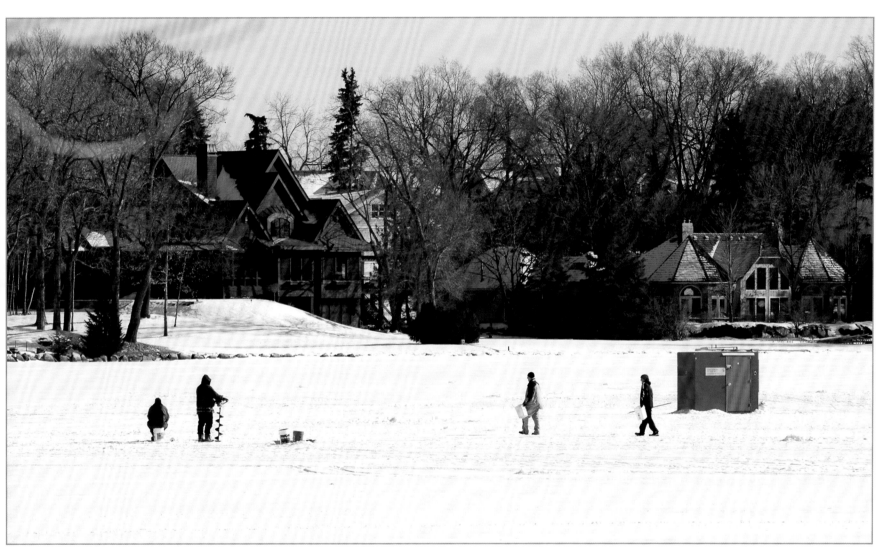

Fish houses can be found on any frozen lake—urban or rural. Lake Minnetonka's beautiful lake homes provide the backdrop for the more modest fish houses.

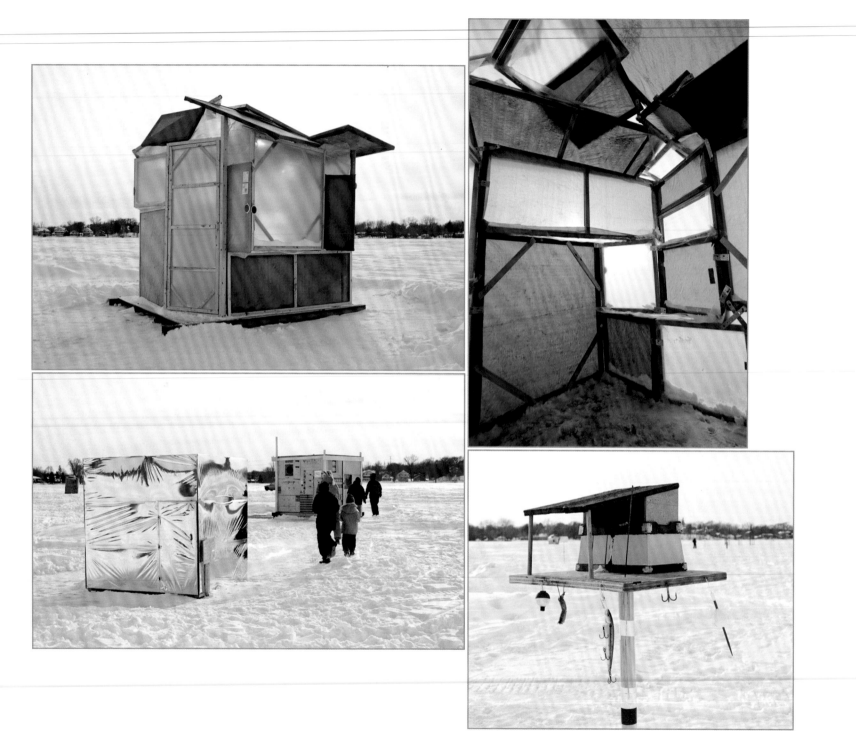

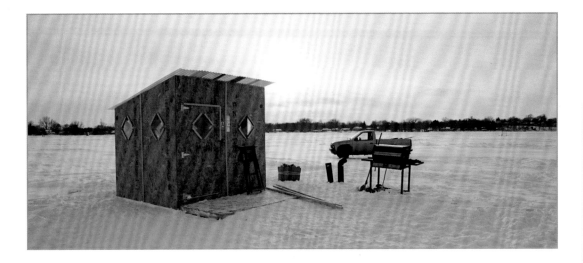

Art Shanty Projects

Sometimes fish houses are not really fish houses at all. Such is the case with the structures created for the Art Shanty Projects on Medicine Lake in Plymouth, Minnesota. Over sixty artists have participated in the projects—making art houses and gathering spaces where many activities take place; ranging from karaoke, to making frozen balloon sculptures, to yoga. Peter Haakon Thompson and David Pitman of the Soap Factory are the guiding lights of this "art-making-in-the-winter-on-a-frozen-lake" venture.

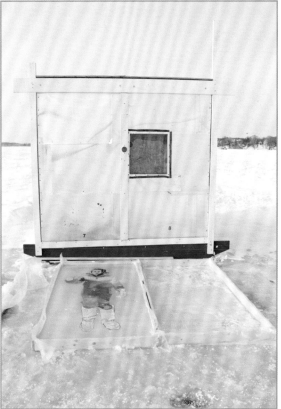

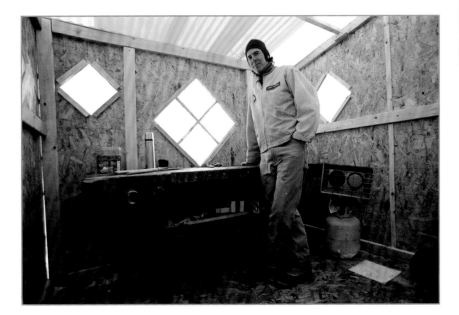

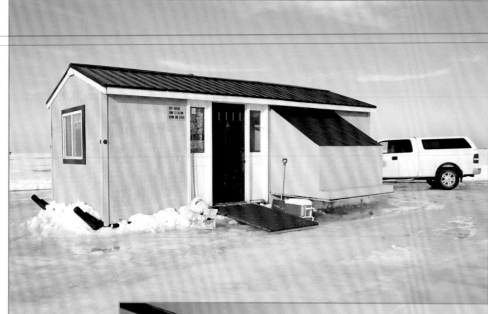

House interiors vary greatly, from utilitarian to all the comforts of home. Starting with the basics of a heater and a seat; bunks, a table and kitchen set-up, comfortable chairs, an indoor bathroom, and even a fireplace may be added. Just like some of the exteriors, walls, floors, and interior finishings allow for individual expression and workmanship. Tongue and groove paneling, curtains, and fish mounts add character. And a generator can provide access to all the creature comforts—including not missing the game on TV.

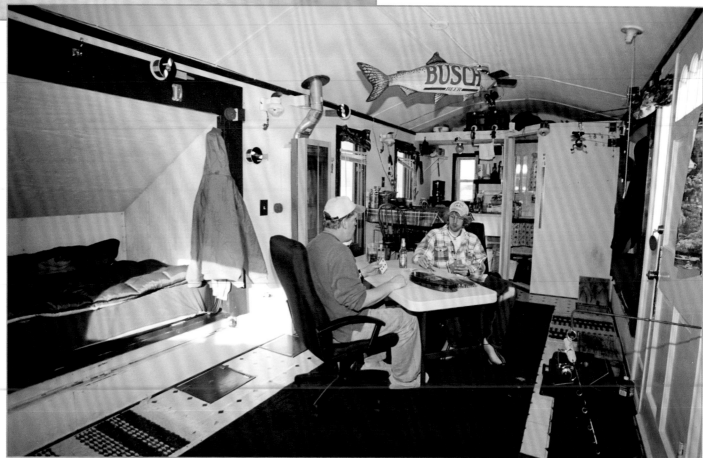

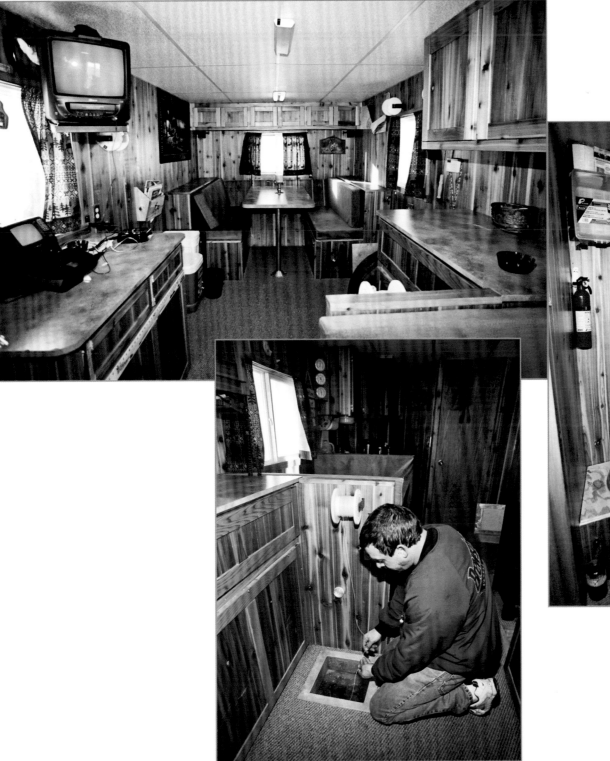
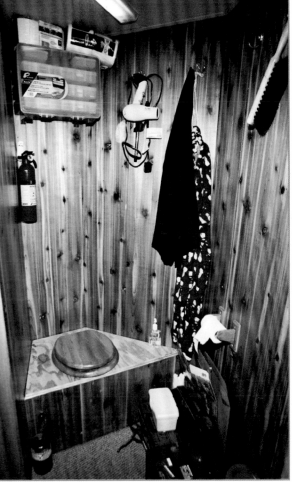

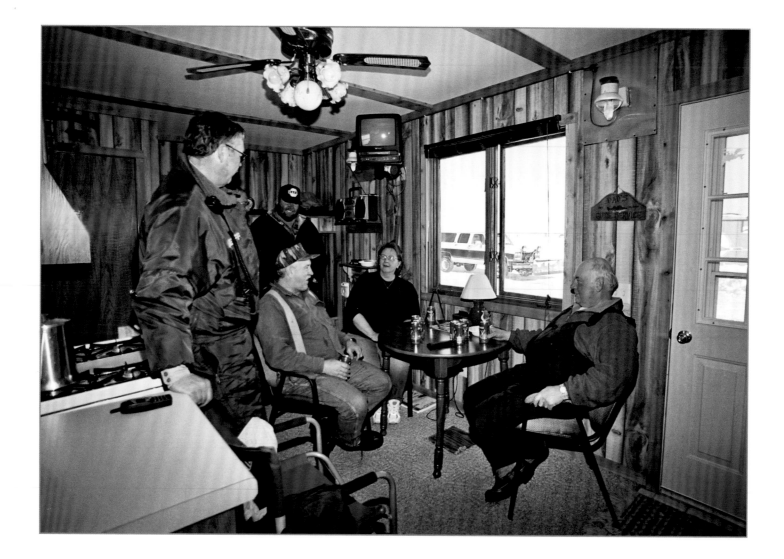

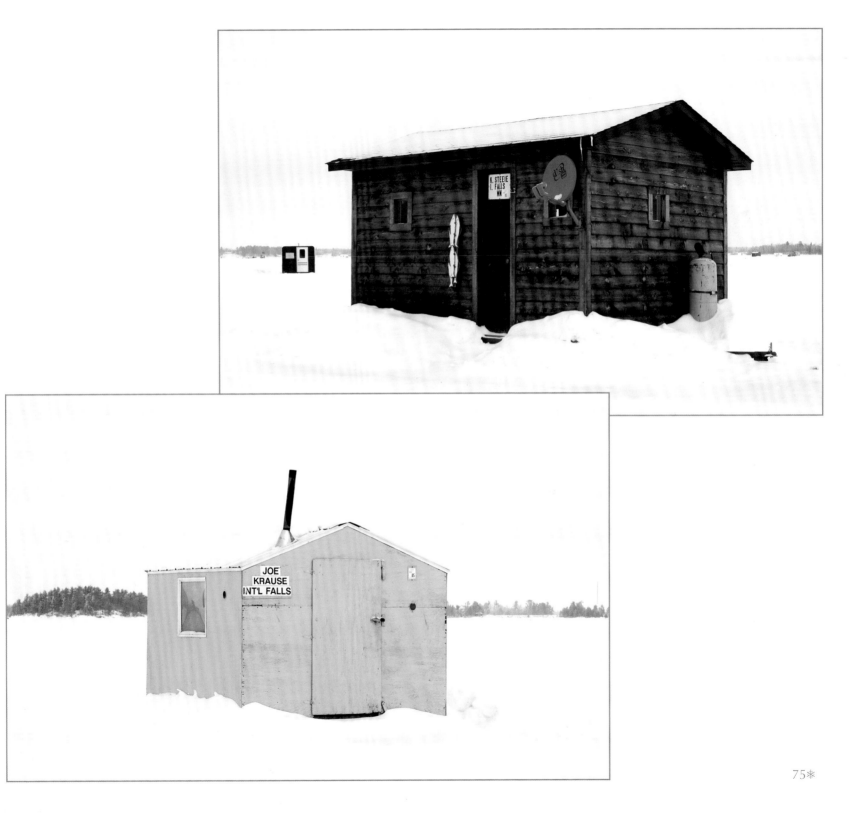

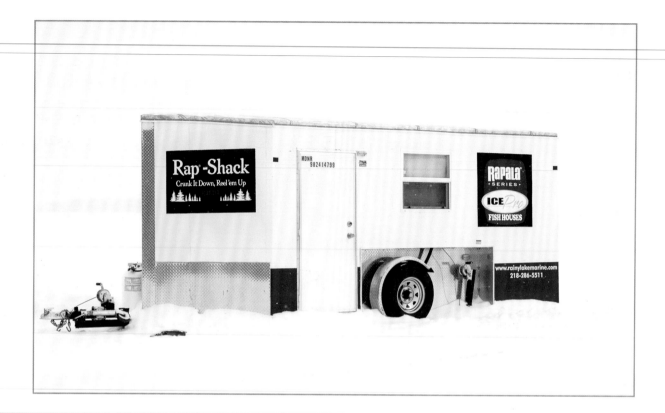

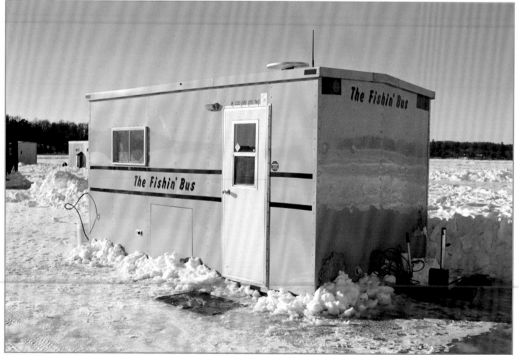

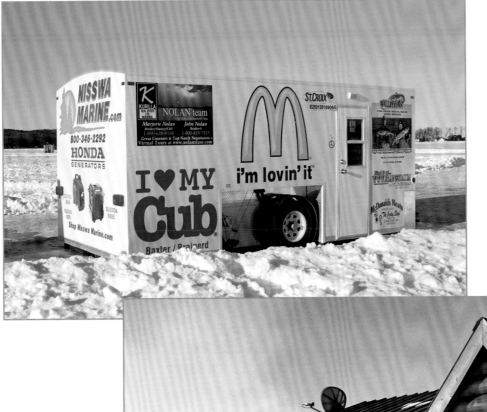

Fish Houses gone commercial—guides and fishing related businesses advertise themselves and their sponsors.

Below - Russell & Herder advertising agency's "Offshore Conference Center" for client meetings.

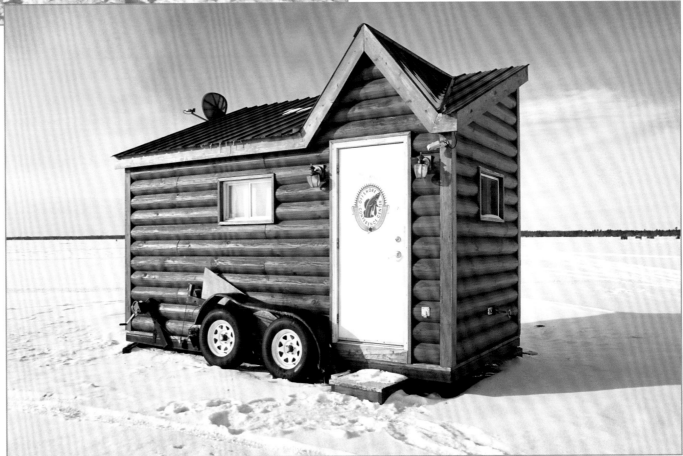

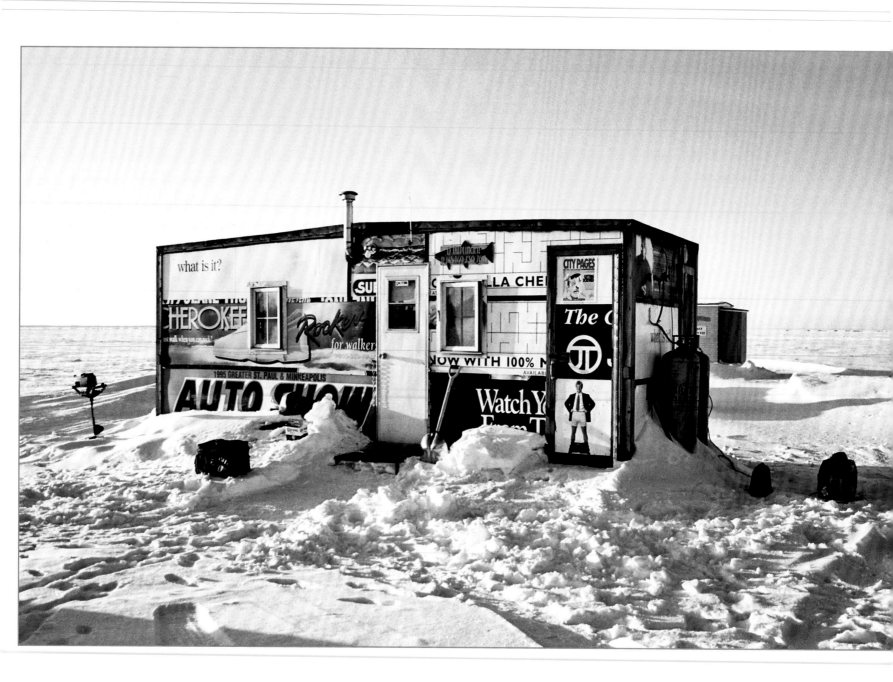

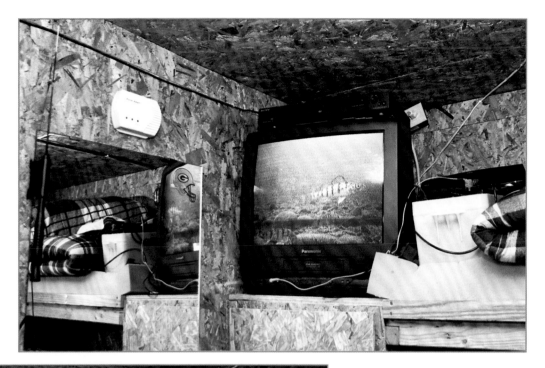

Perch TV
An underwater camera captures the
view underneath the ice.

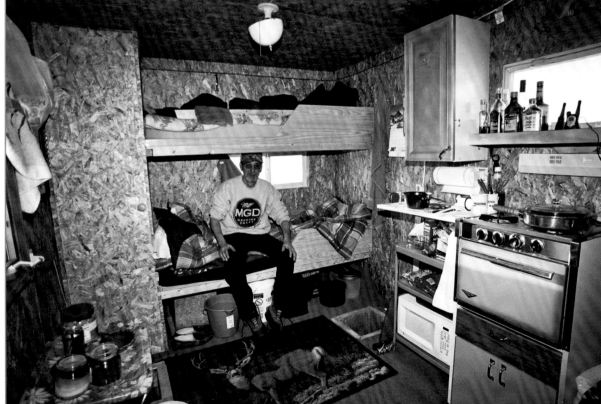

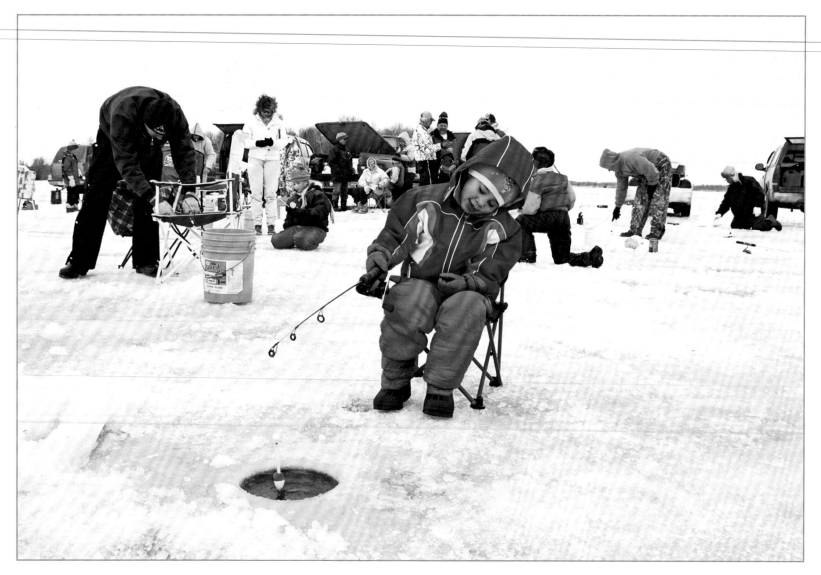

Fishing Contests

Fishing contests have become extremely popular winter recreational events that draw anywhere from a hundred to many thousands of anglers. They are often sponsored by civic organizations with proceeds being used for charitable causes. Anglers of all ages fish, socialize, and vie for prizes—autos, trucks, ATVs, cash, and much more. The contests are not only recreational, but can also provide economic bonanzas to the communities that host them. In the 2005-06 season, 86 contests of 150 anglers or more were scheduled on Minnesota lakes. However climate-warming trends, which have affected the quality of ice, forced the cancellation of almost twenty contests—mostly in southern and central areas of the state. Other contests are moving farther north. For example, the Golden Rainbow tournament will be moving from Forest Lake to Pokegama Lake near Grand Rapids in 2008. According to the Minnesota Department of Natural Resources, the number of safe ice days is shrinking by 30 to 60 days in some parts of Minnesota and Wisconsin.

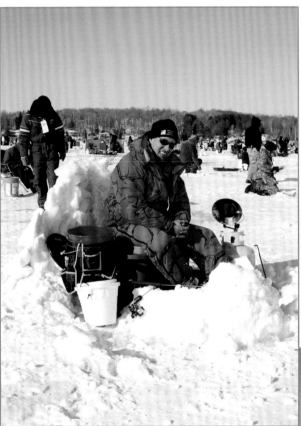

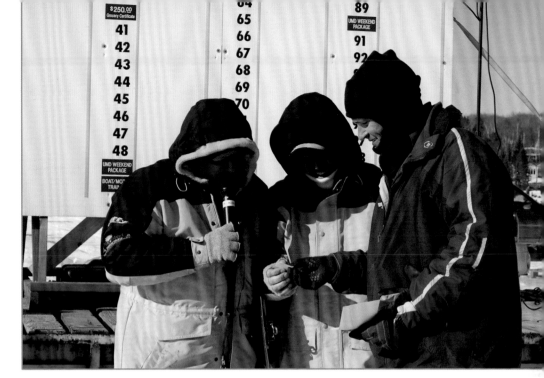

Pro fishermen and hosts, Scott and Marty Glorvigen, check out winning tickets at the Big Jig Ice Fishing Contest and Festival on Pike Lake.

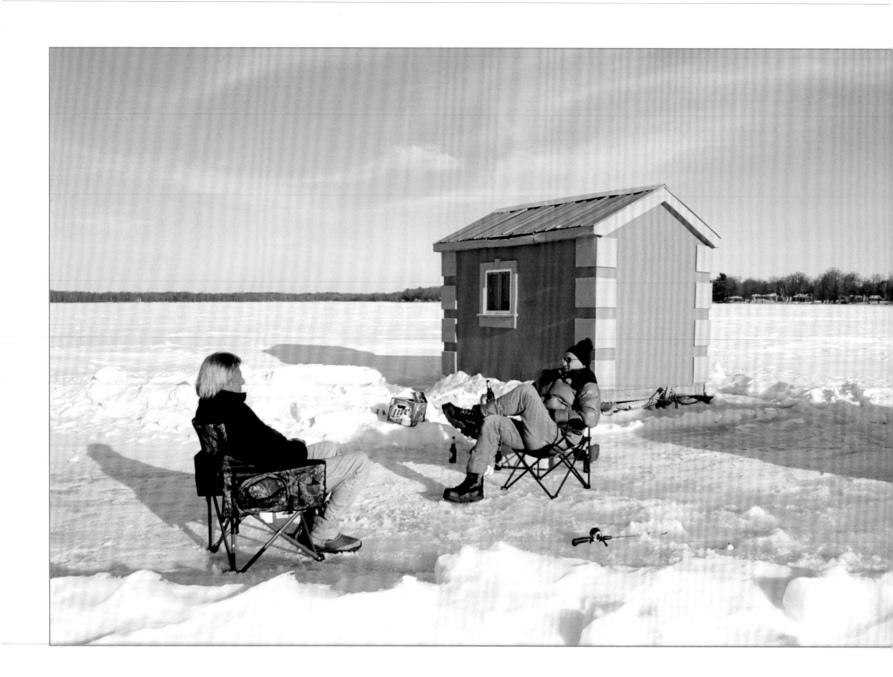

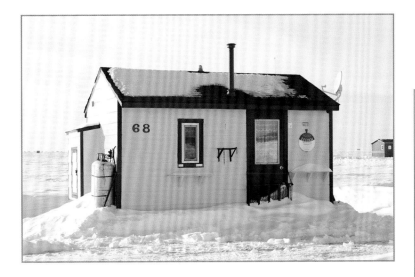

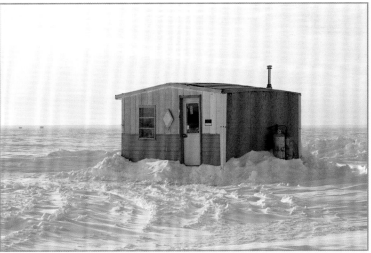

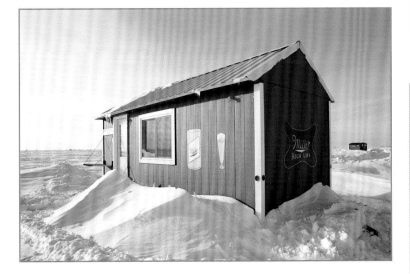

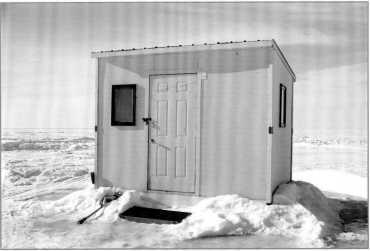

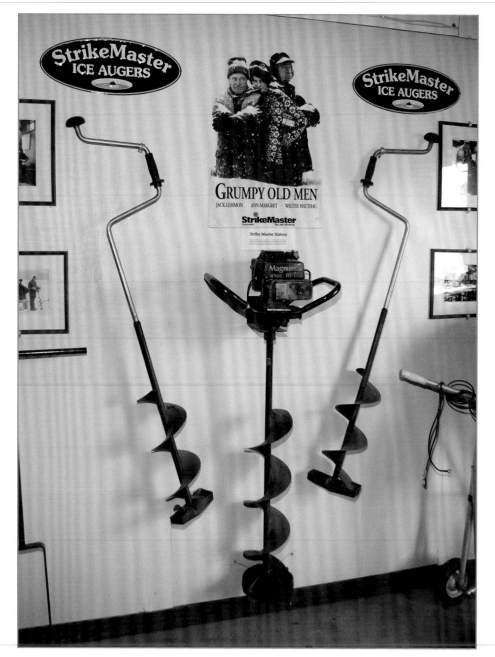

The 1993 movie, *Grumpy Old Men*, brought the sport of ice fishing to the entire country. Jack Lemmon, Walter Matthau, and Ann-Margaret star in this tale of two squabbling old neighbors who fish in side-by-side fish houses and compete for the attention of a new woman in the neighborhood. The movie is set in Wabasha, Minnesota, home of screenwriter Mark Steven Johnson's grandparents. It was filmed in a number of Minnesota locations.

The ice auger used in the making of the movie is on display at the headquarters of StrikeMaster in Big Lake, Minnesota. The auger was "aged" for an authentic well-used look.

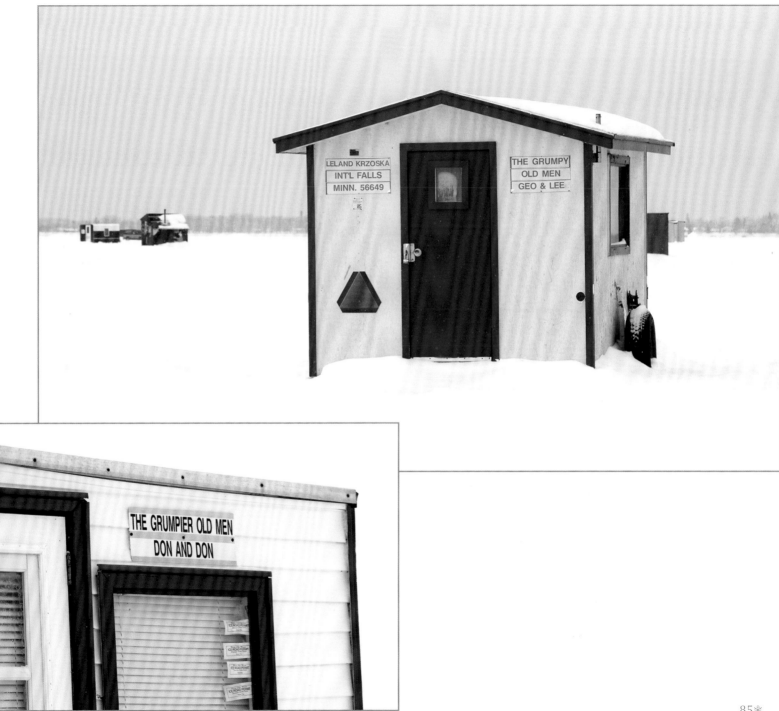

Dark houses, such as the one on the left, are used for spearing rather than angling. They have no windows in order to provide visibility into the fishing hole, which is much larger than an angling hole.

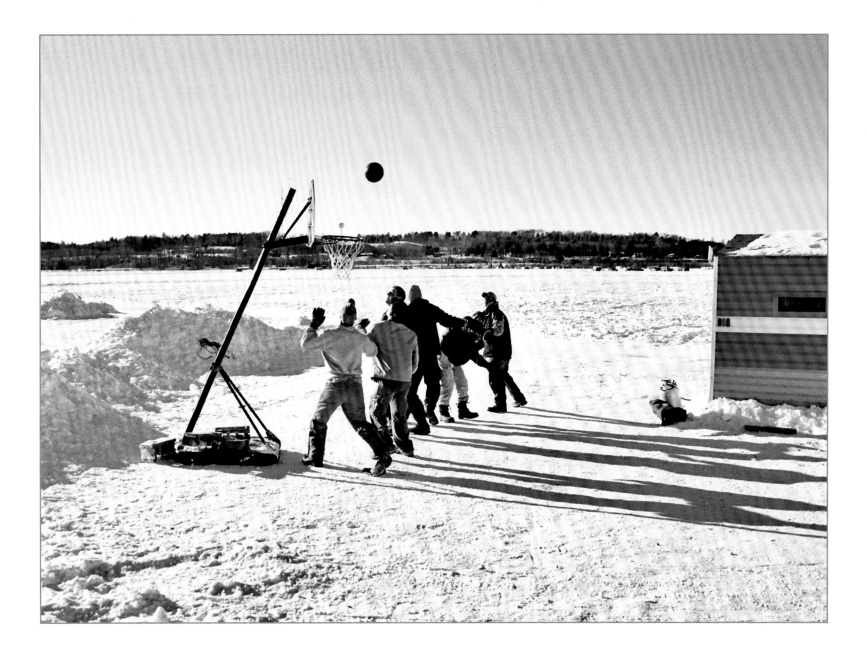

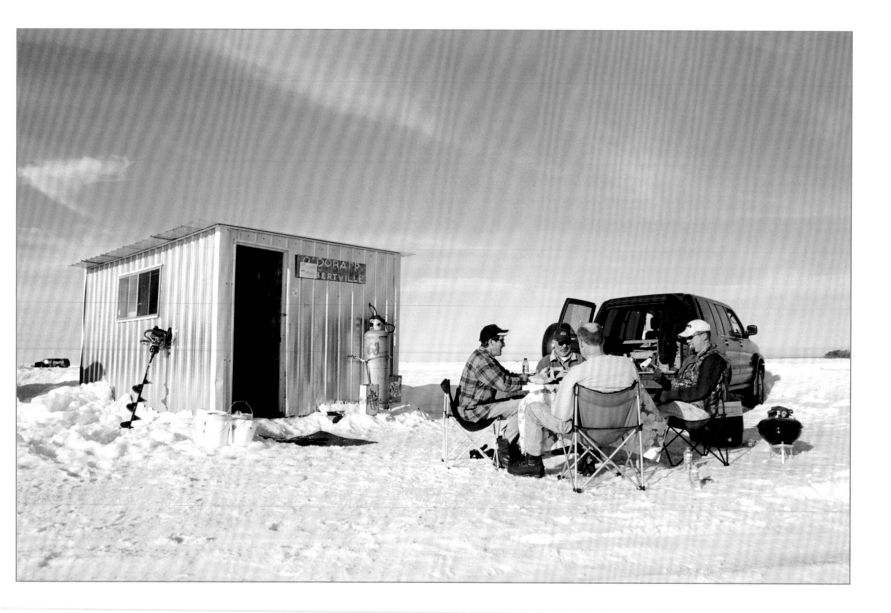

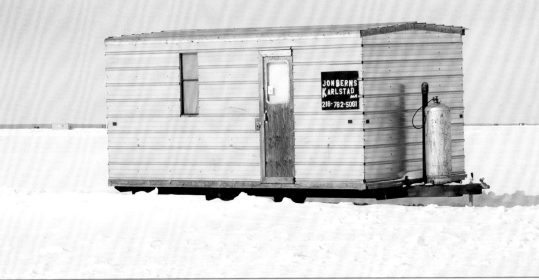

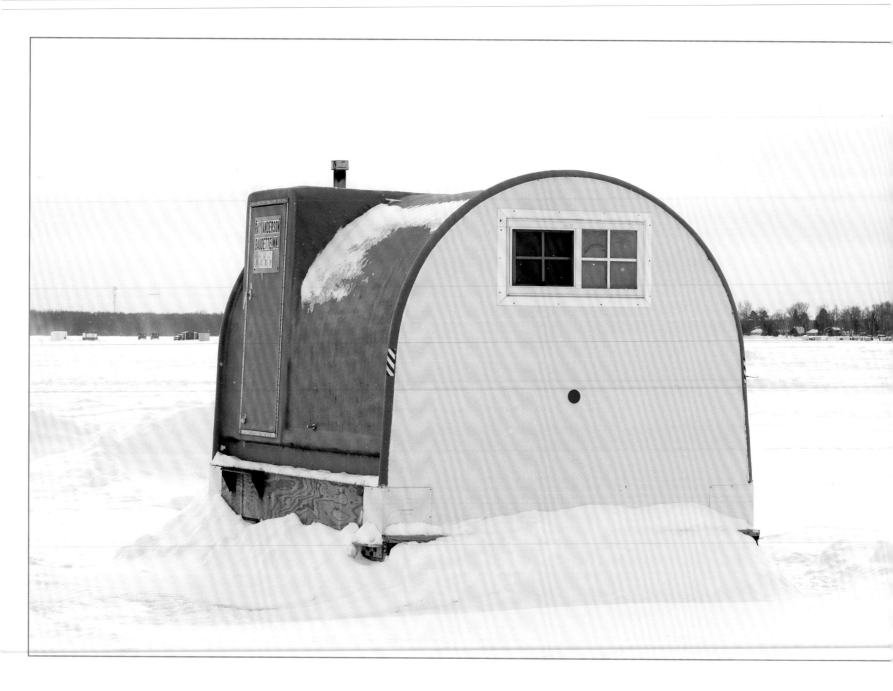

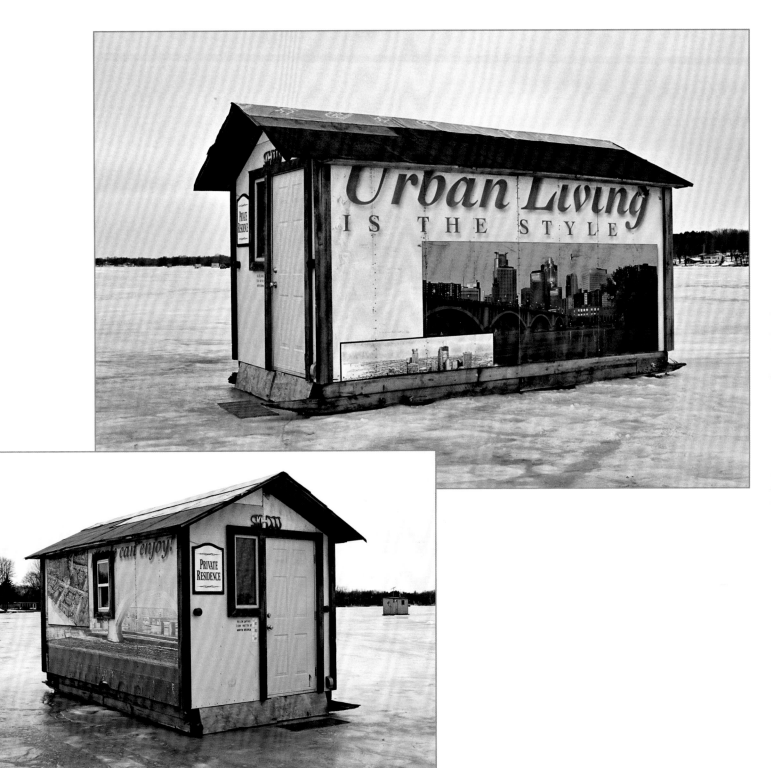

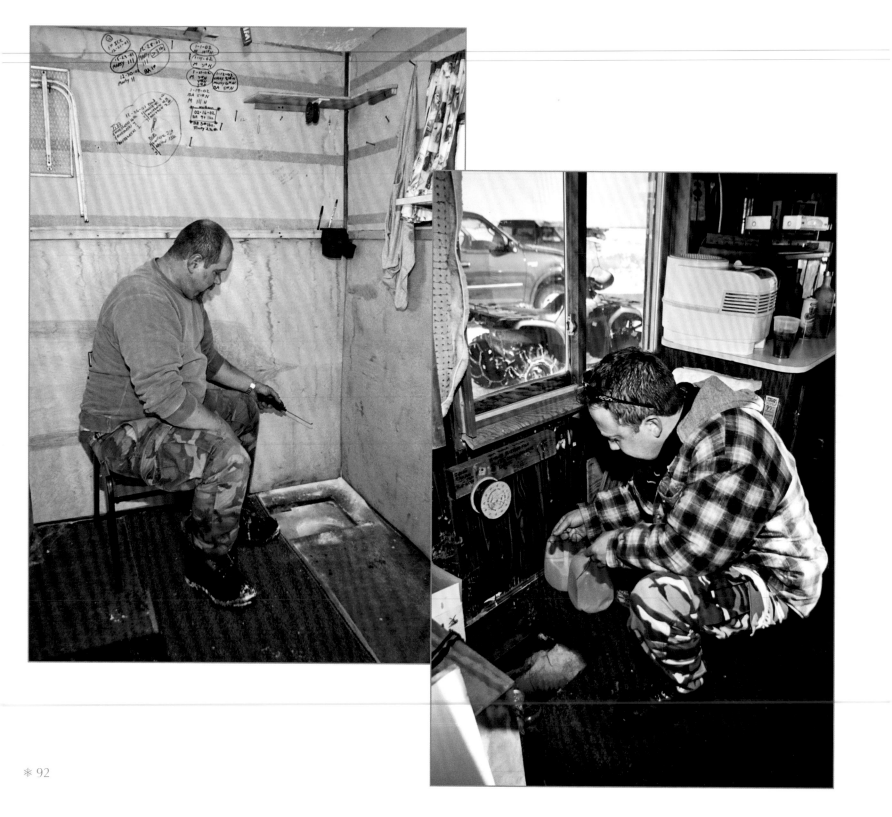

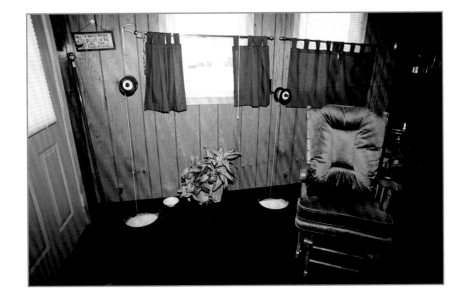

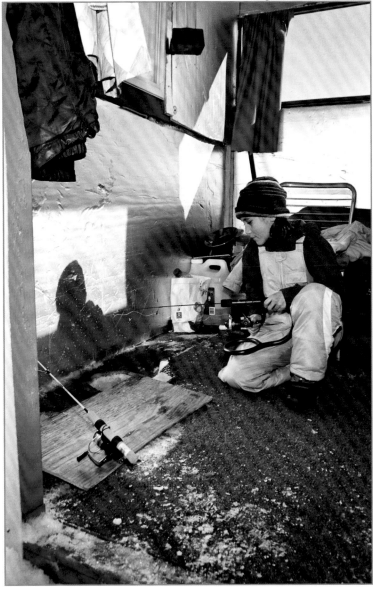

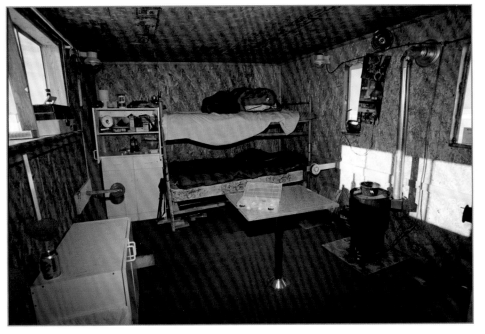

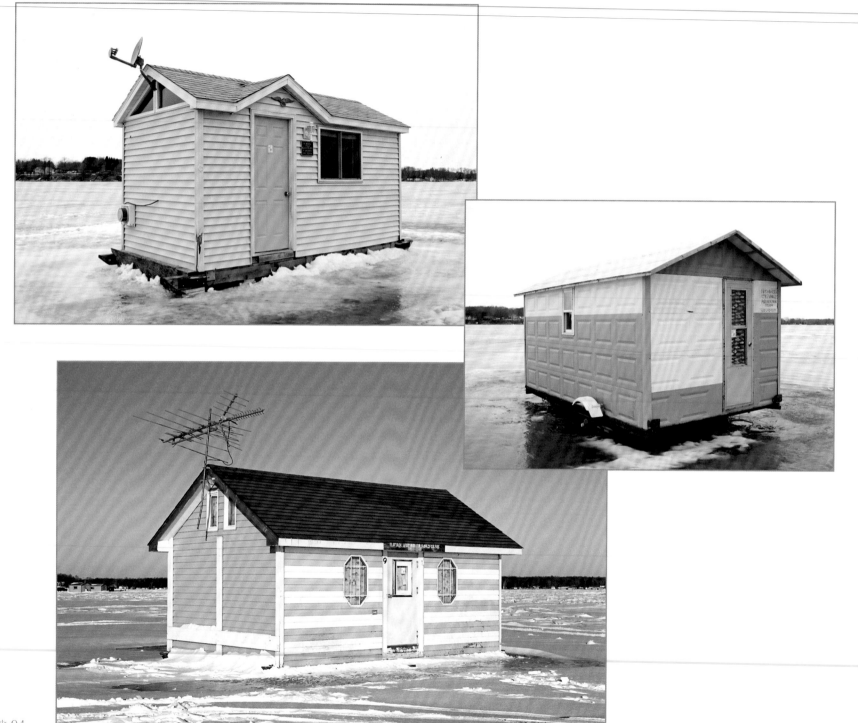

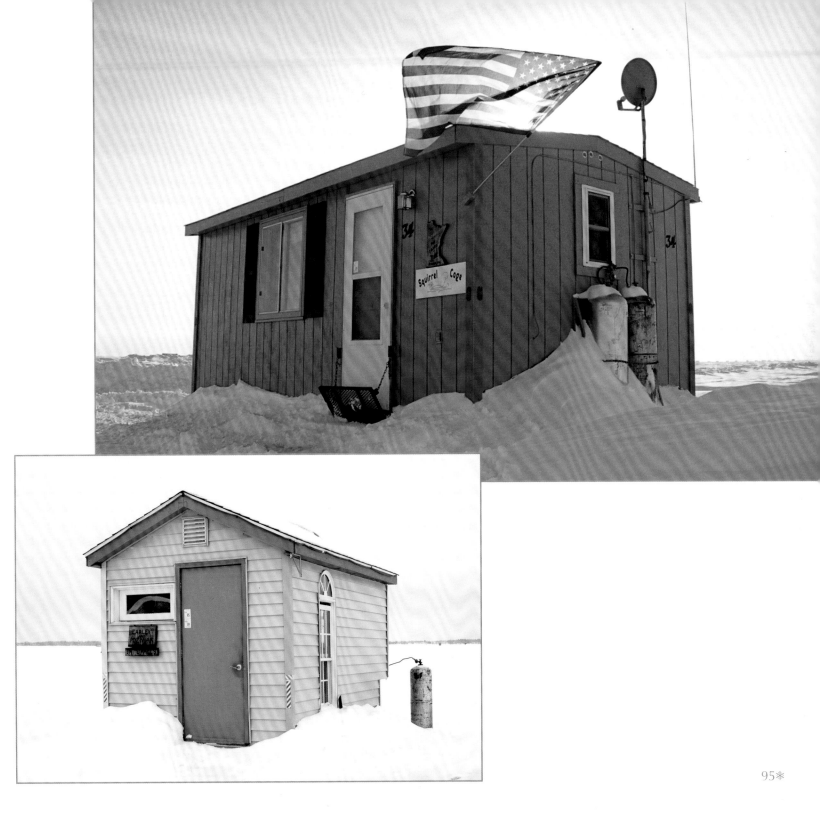

An hour after this photograph was taken, all of the ice was gone at the mouth of the French River near Duluth, Minnesota.

Open water is visible on Lake Superior.

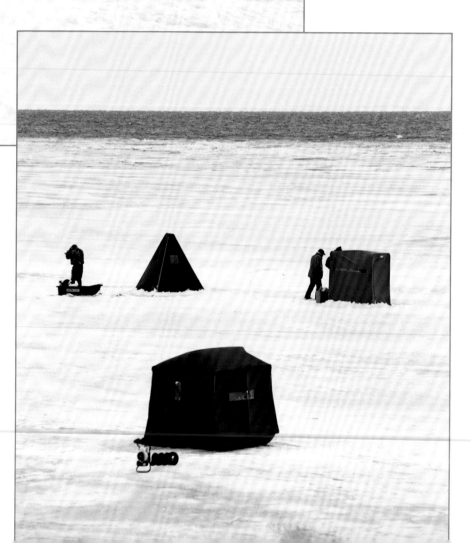

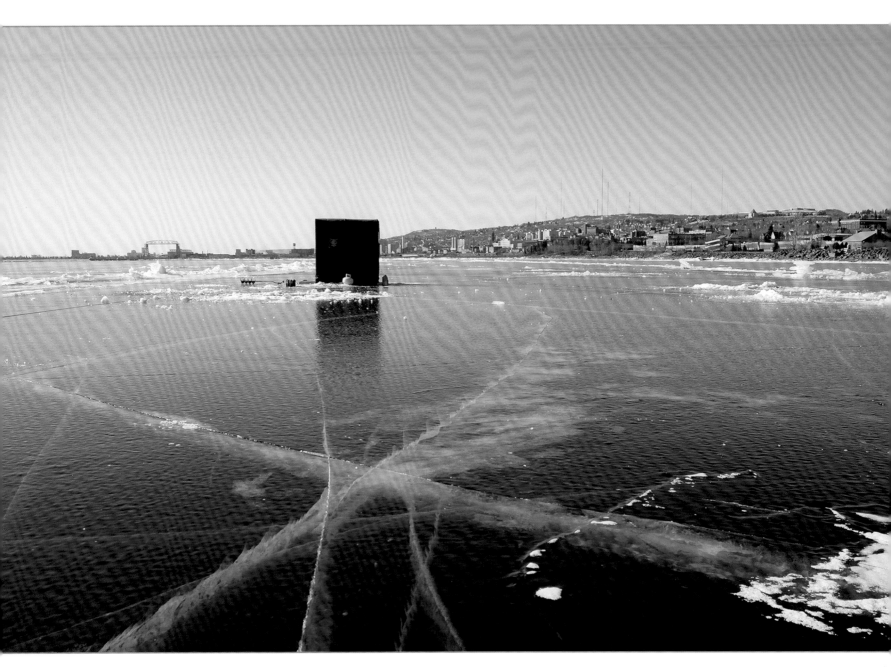

February on Lake Superior with the Duluth hillside as the backdrop. Lake Superior, the world's largest freshwater lake, very rarely freezes over completely. It maintains an average annual water temperature of 40º Fahrenheit and its freezing period ranges from November to April. In February of 2007, Duluth residents were treated to 10 inches of crystal-clear, mostly smooth ice that allowed for skating, exploring, and fishing time with portables.

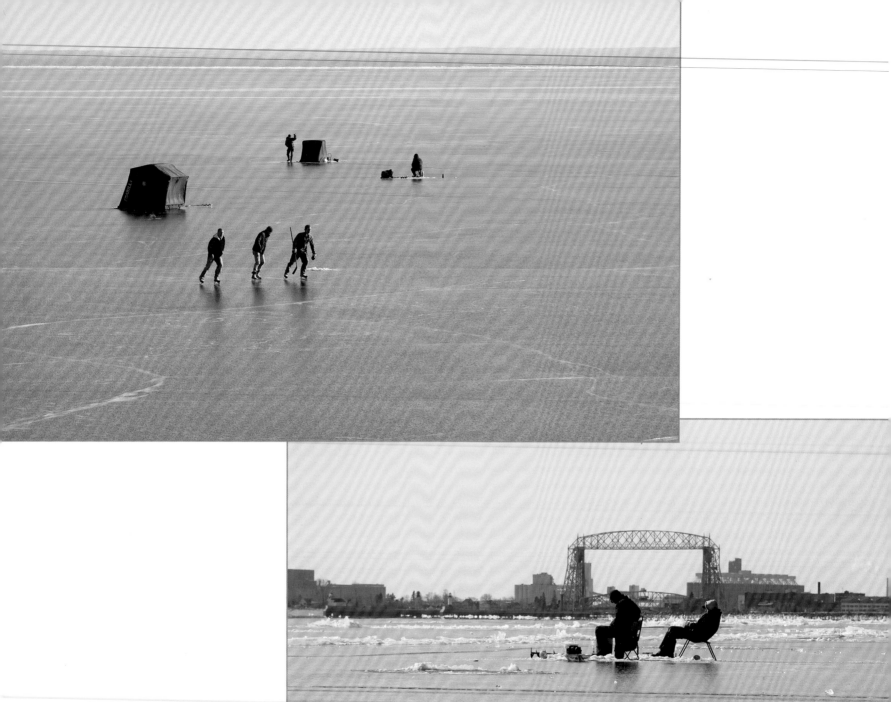

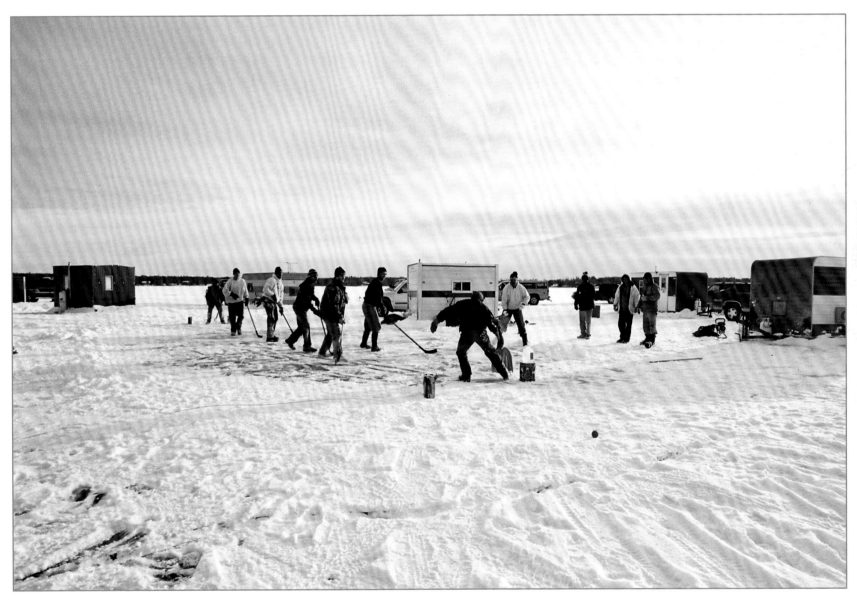

Boot hockey on Round Lake, Brainerd, Minnesota.

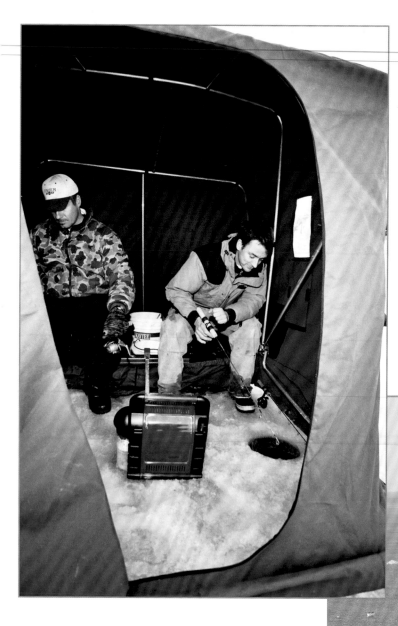

Portable Fish Houses

Portable fish houses or huts are gaining in popularity among anglers and are changing the sport of ice fishing. They offer comfort, ease of set up, and mobility. Constructed of materials such as nylon, canvas, or poly cotton, these houses come in a wide variety of sizes, weights, and colors. Some are mounted on self-contained transport sleds. Fishers sit in the toasty warm huts, sheltered from the elements. Using portables and electronics, anglers can move quickly to check out new fishing spots with the ultimate goal of catching more fish. Ice fishing electronics continue to become more sophisticated with sonar/GPS units, flashers, underwater cameras, and hand-held digital depthfinders available to help find the fish.

Portables are used on Lake Superior where ice conditions can change very rapidly.

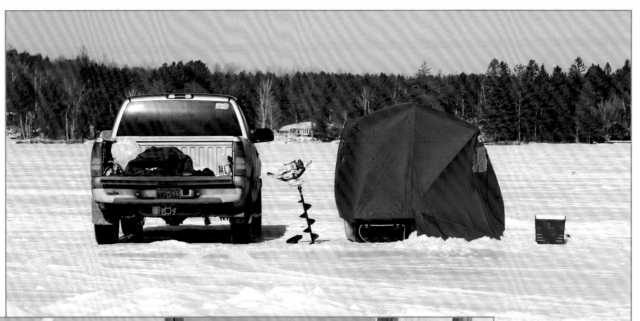

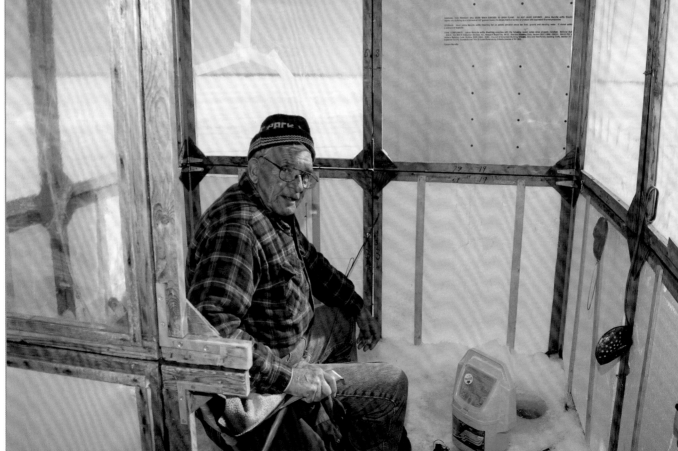

A homemade portable with a view on Upper Red Lake.

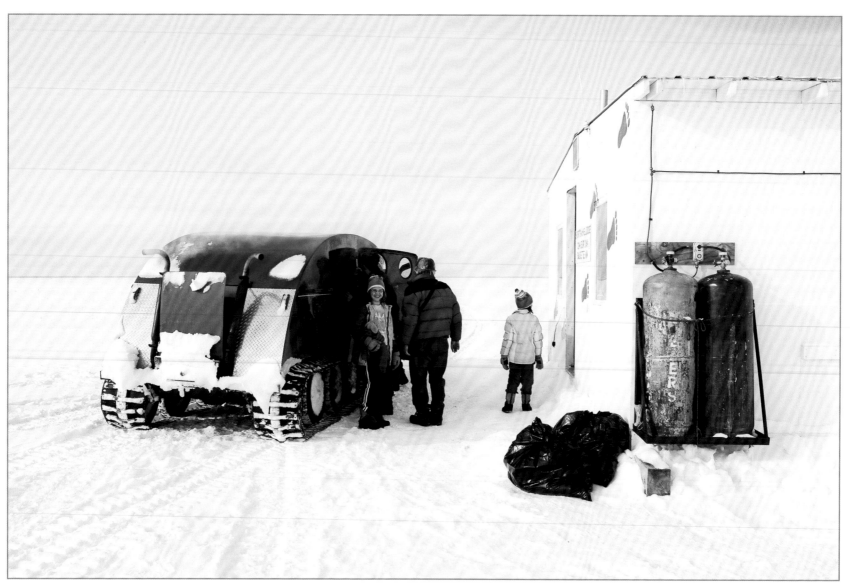

Loading up after a two day family vacation on Lake of the Woods.

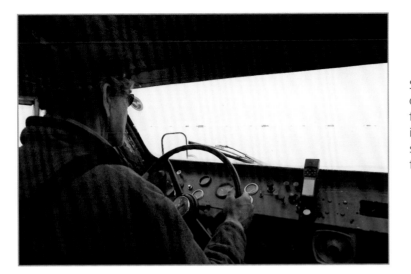

Sleeper houses are set up for staying out on the ice overnight. They are the ultimate in getting away from it all. Track vehicles take you miles out on the ice to your house. Equipped with a furnace, lights, stove for cooking, bunkbeds, and a two-way radio for emergencies, you are ready for fishing 24/7.

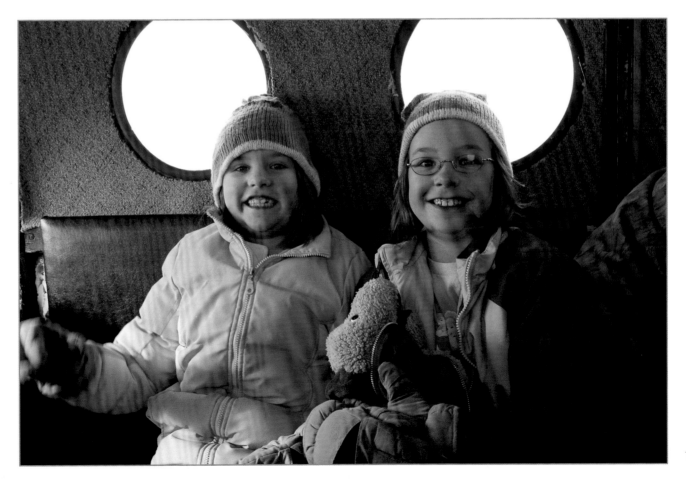

103✳

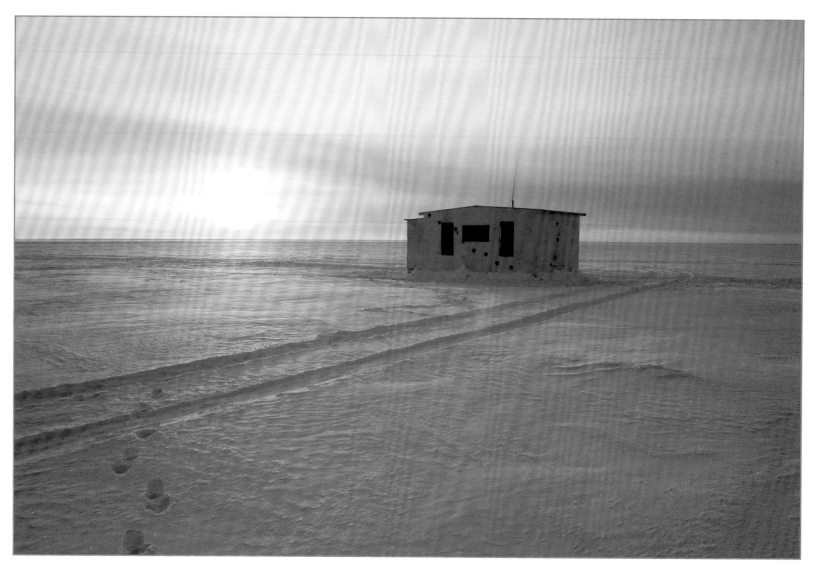

Sunset on Lake of the Woods.

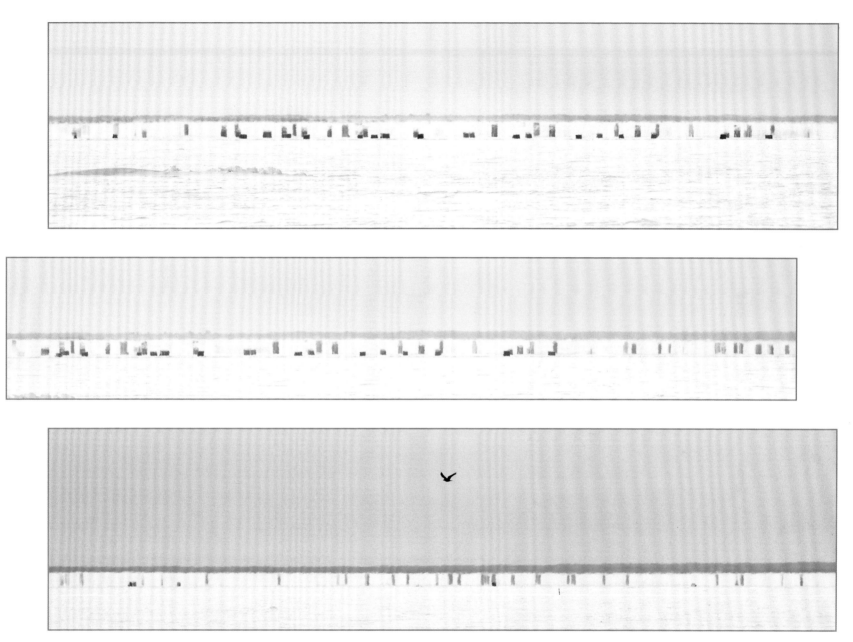

Towering fish house mirages at sunrise on Lake of the Woods. Air temperature was negative 7º Fahrenheit.
Superior mirages form when cold air lies beneath relatively warmer air and the light rays bend downward.
The short, dark blocks are actual fish houses and the lighter, taller rectangles are all mirages.

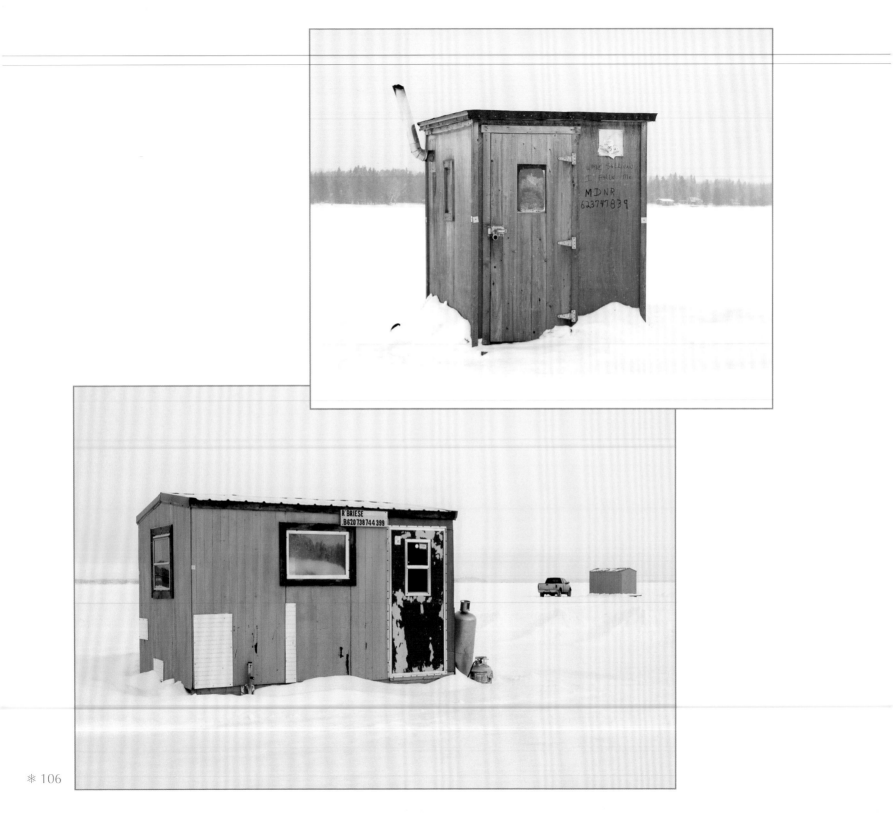

Fog on White Bear Lake.

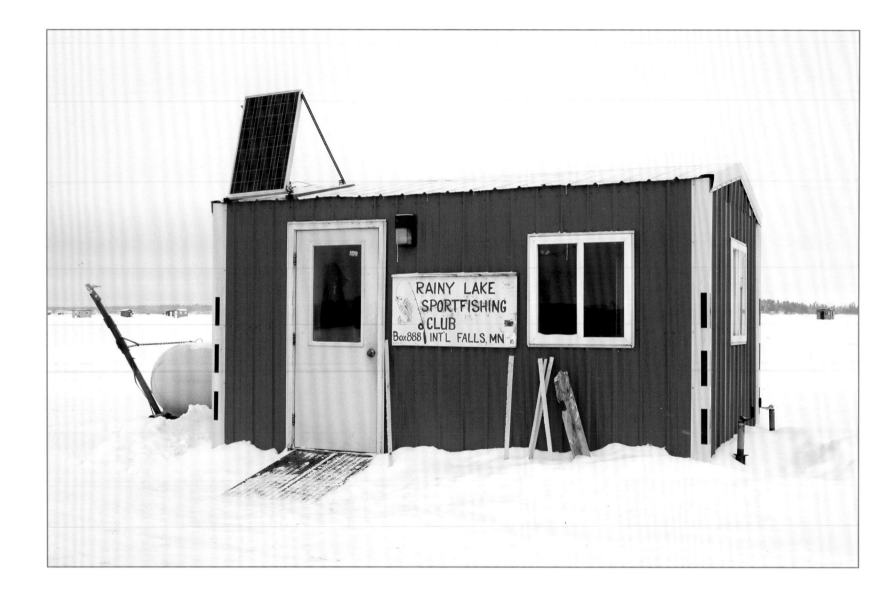

For twenty years fishermen have gathered at the Rainy Lake Sportfishing Club near International Falls, Minnesota. The house provides a place to fish, play cards, and socialize without the hassle of maintaining private houses. A solar panel provides electricity for lights and an electric auger.

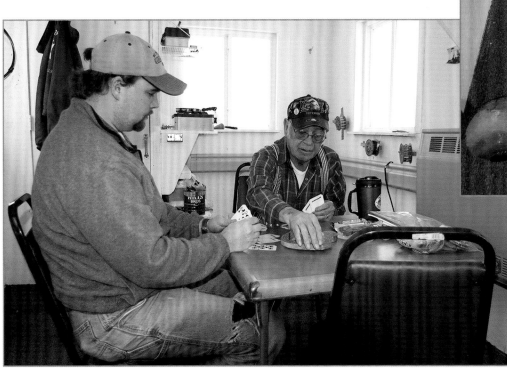

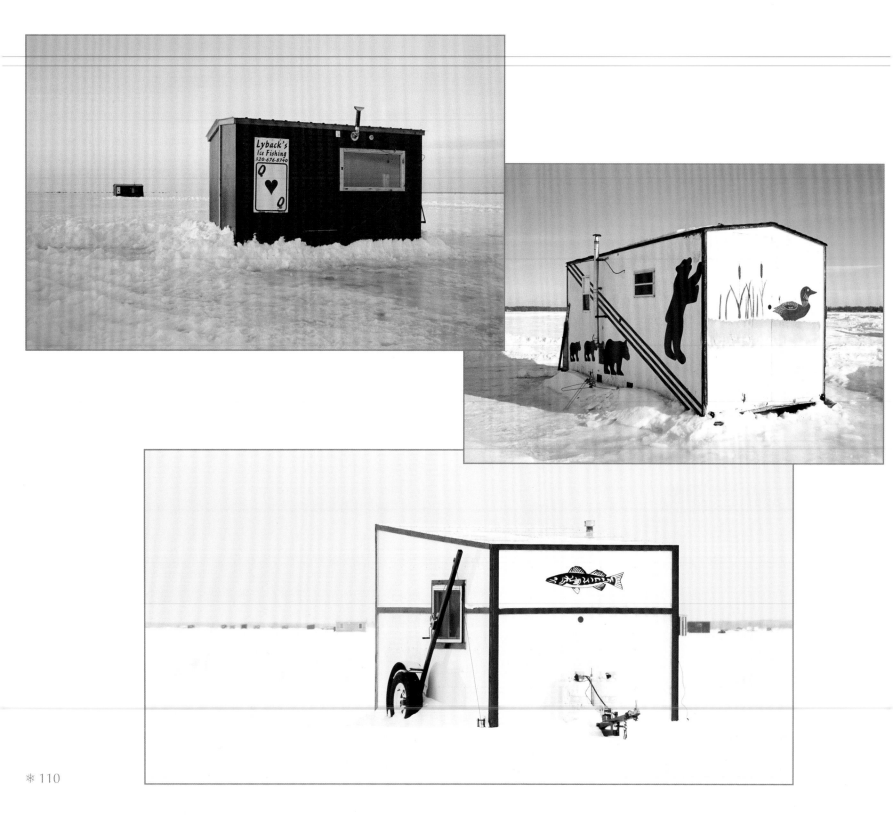

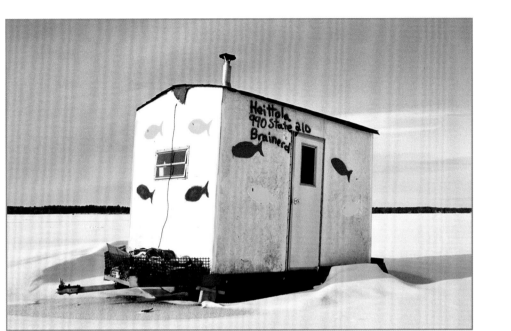

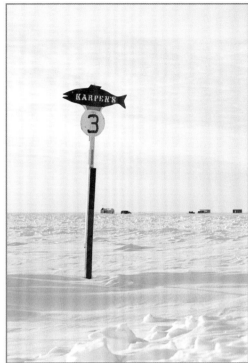

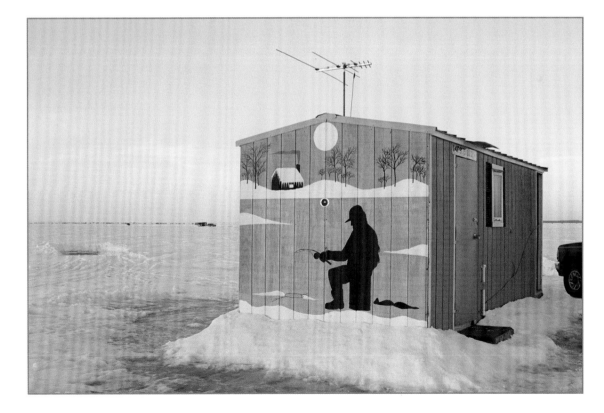

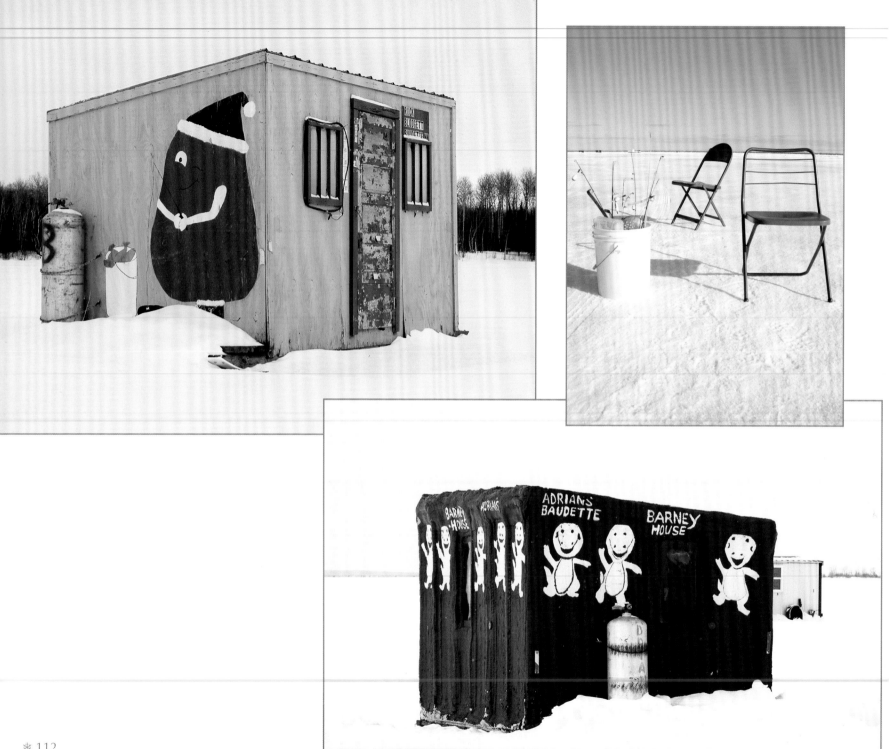

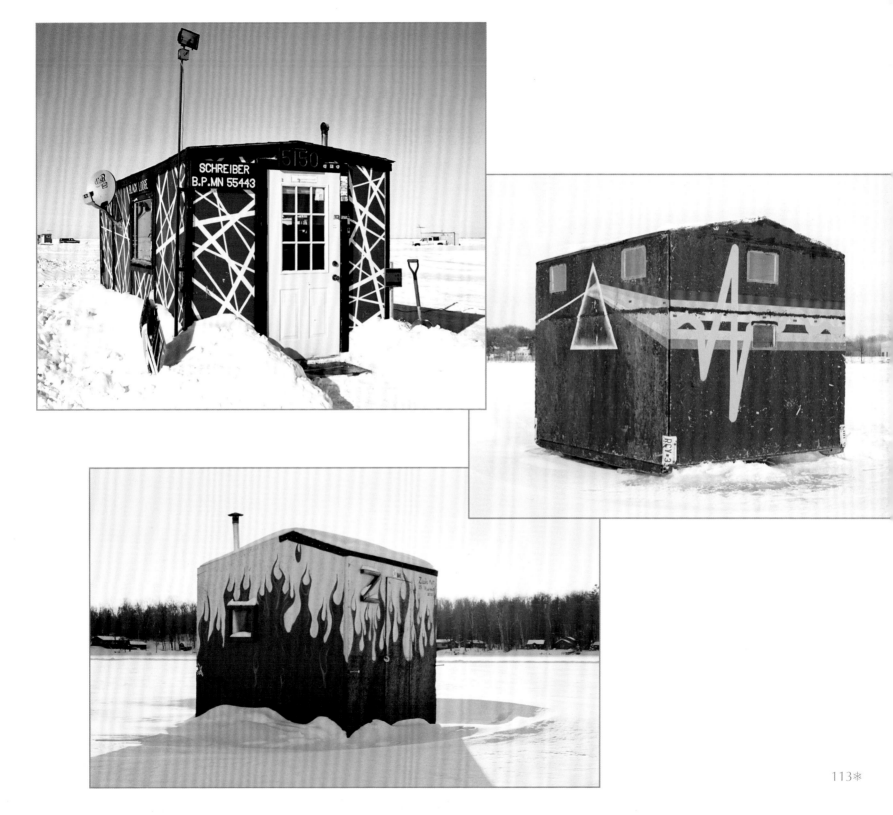

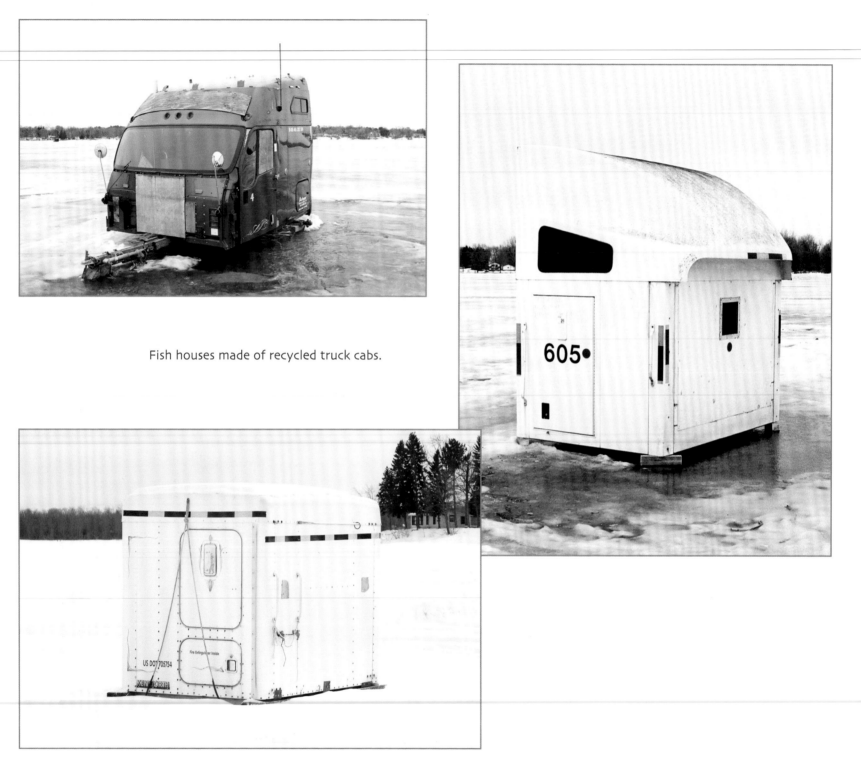

Fish houses made of recycled truck cabs.

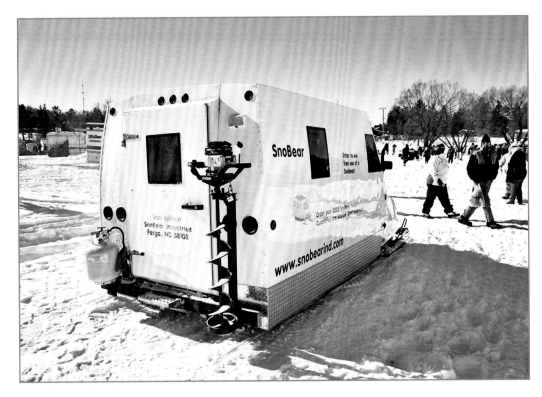

The SnoBear is an innovative vehicle that combines characteristics of a car, snowmobile, and boat in a mobile fish house that can be driven onto the lake and lowered to the ice ready for fishing. A heated, insulated cabin with fold-down beds provides comfort for overnight stays. And for the ultimate in safety, the SnoBear is designed to float should the need arise.

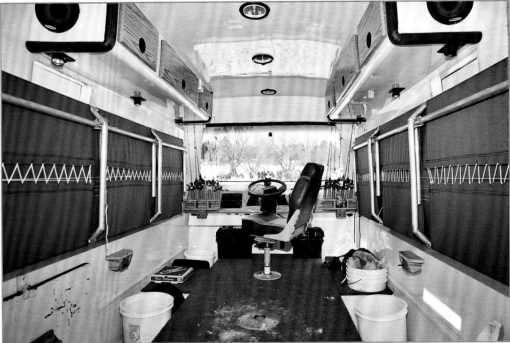

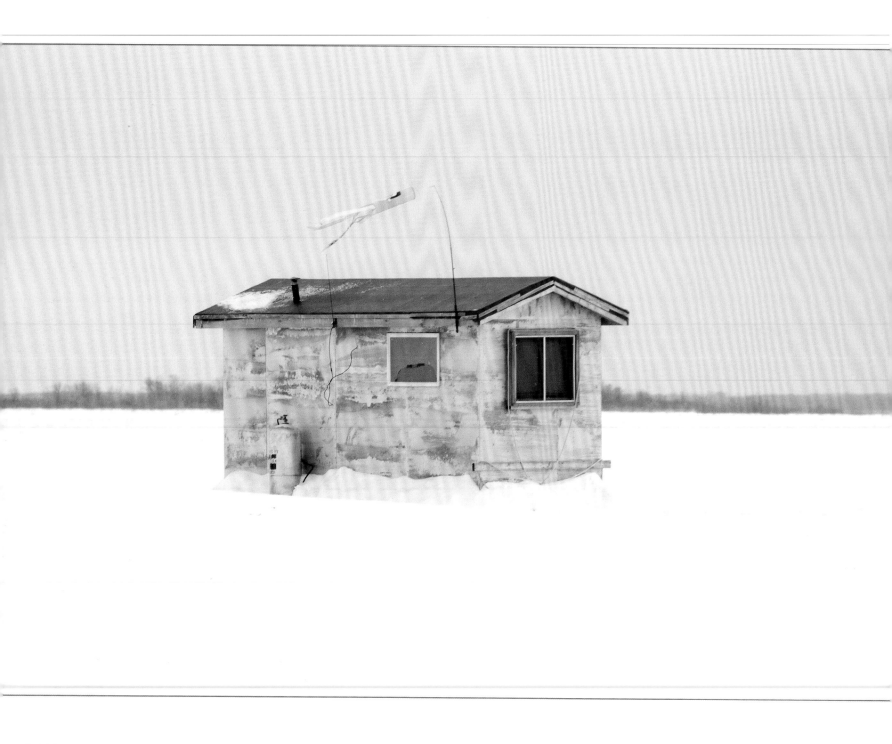

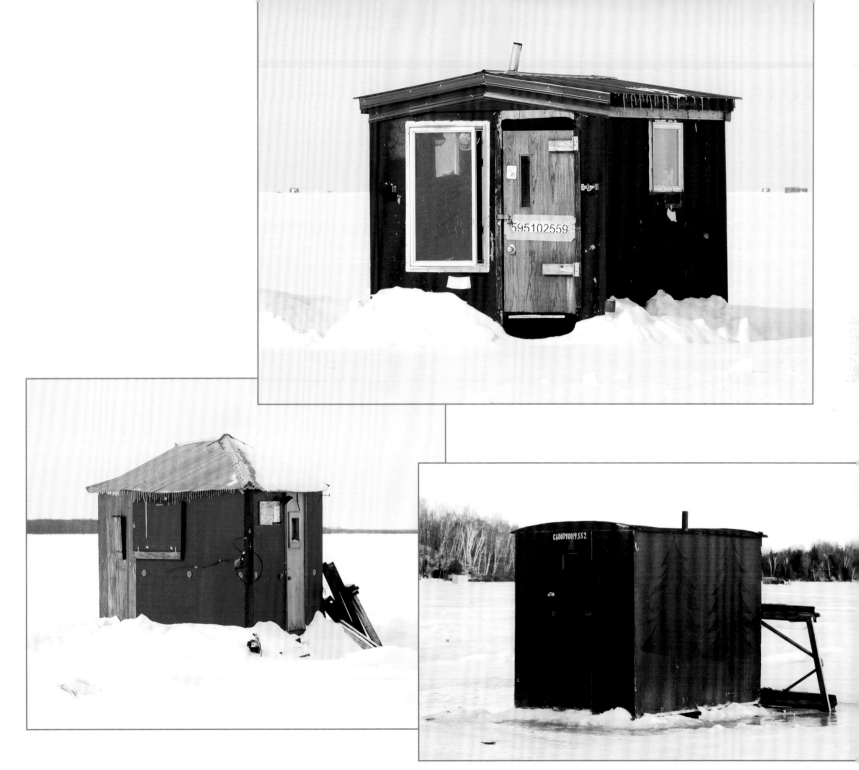

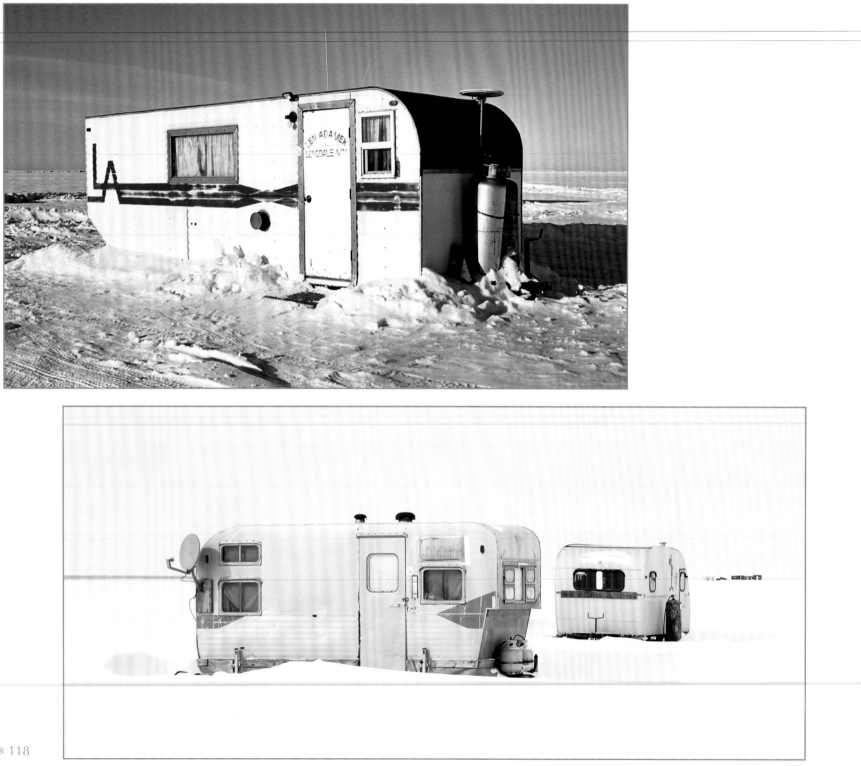

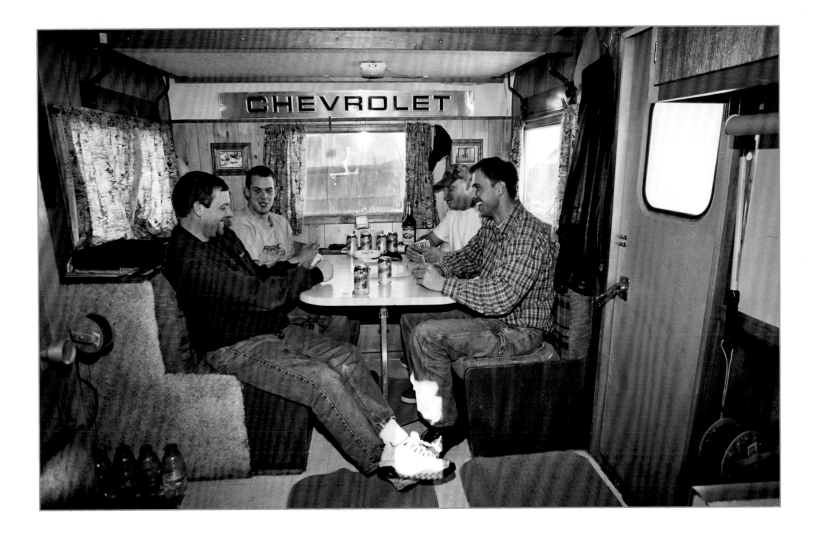

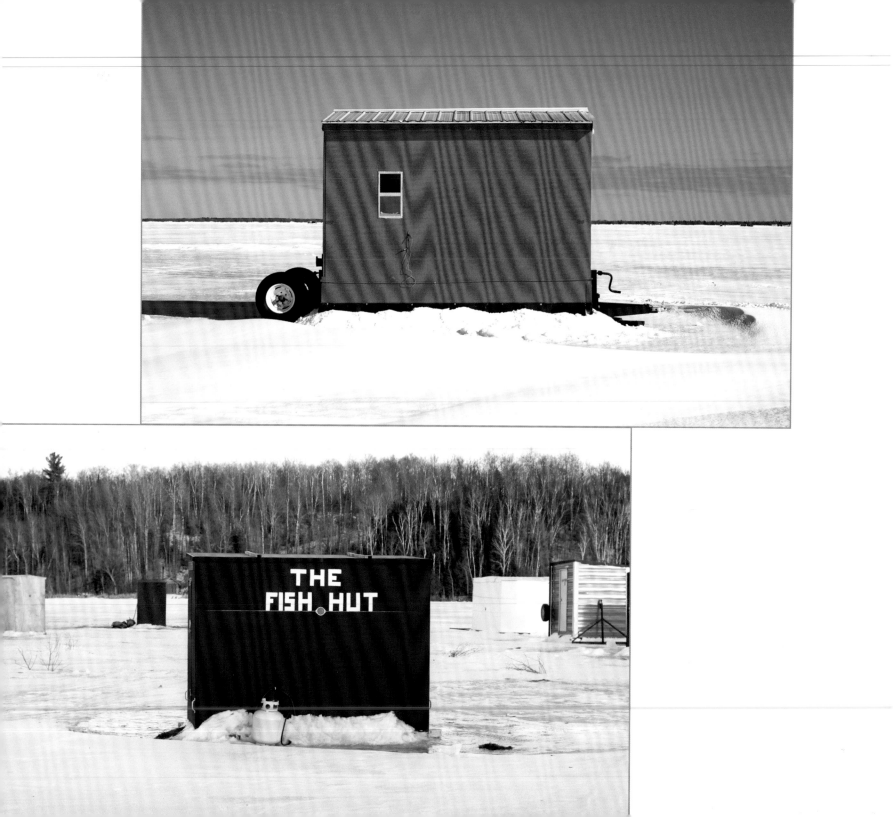

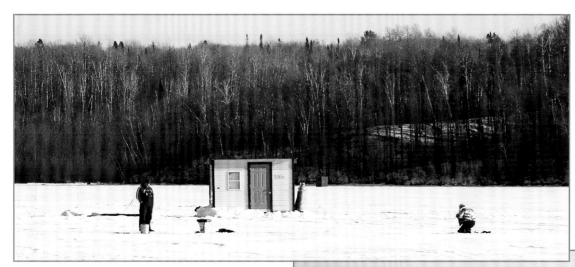

Fish houses are found on rivers as well as lakes.

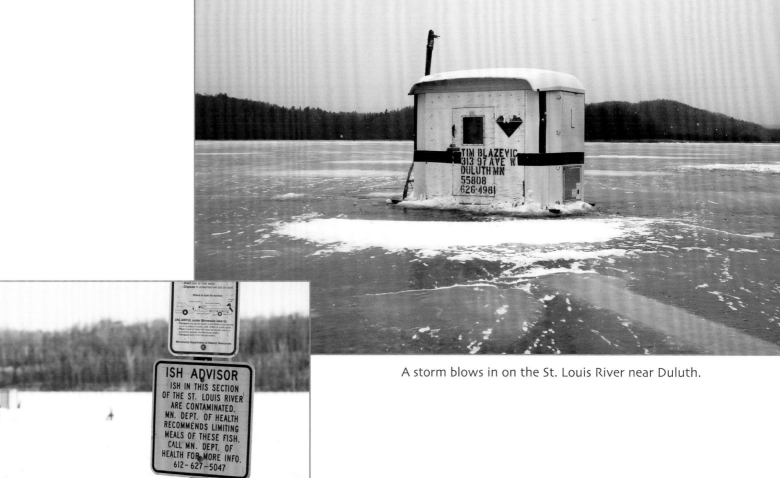

A storm blows in on the St. Louis River near Duluth.

ISH ADVISOR
ISH IN THIS SECTION
OF THE ST. LOUIS RIVER
ARE CONTAMINATED.
MN. DEPT. OF HEALTH
RECOMMENDS LIMITING
MEALS OF THESE FISH.
CALL MN. DEPT. OF
HEALTH FOR MORE INFO.
612-627-5047

Lake ice takes on many incredible forms.

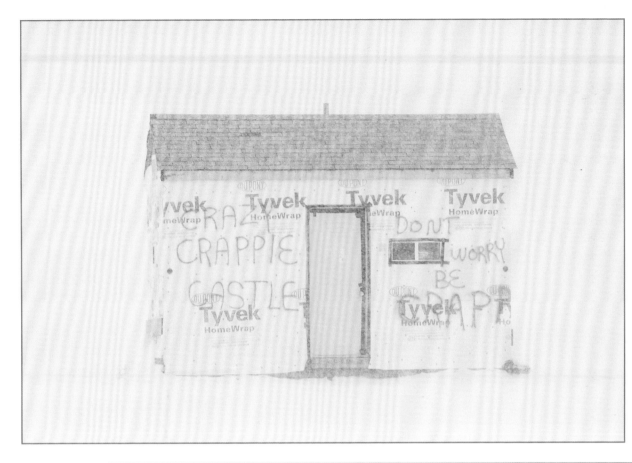

Whiteout on Upper Red Lake.

Weather can change quickly and dramatically during the winter. Within minutes this squall made driving almost impossible.

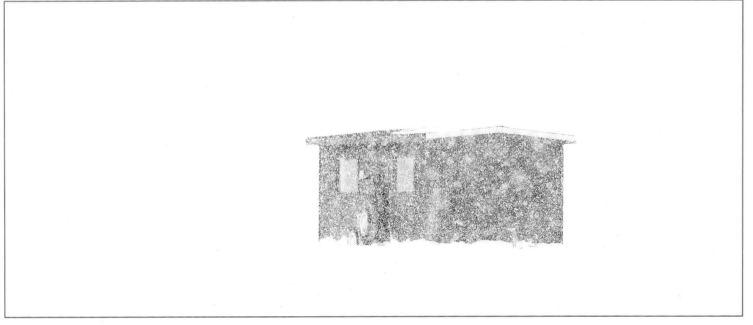

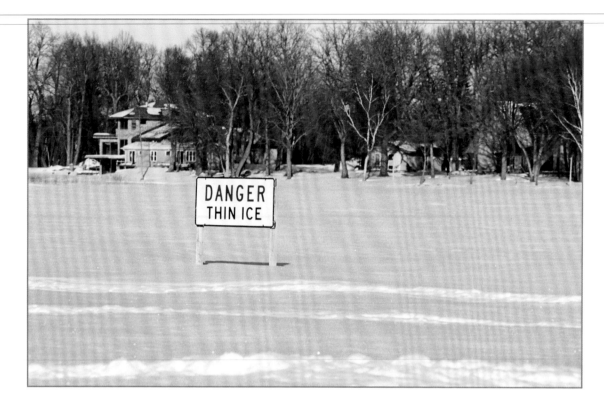

There is no such thing as 100% safe ice!

With over 140,000 ice fishing shelter licenses sold in Minnesota during the 2006-07 season, safety is an issue to be taken seriously. State Departments of Natural Resources provide good information and guidelines for safety through printed materials and on websites.

For example, here are some basic recommendations for minimum ice thickness:
4 inches of new clear ice is the minimum thickness for travel on foot
5 inches is minimum for snowmobiles and ATVs
8 – 12 inches is necessary for cars or small trucks

Ice conditions are posted frequently on various websites and official house removal dates are established and enforced by the states. Other regulations have also been set. Fish houses are required to be identified and licensed. Owners' names, addresses, and numbers must be prominently displayed on all houses. Doors must open from the outside; houses must be spaced at least ten feet apart and have reflective material if they are left out overnight. Unfortunately, every year a few houses, vehicles, and anglers fall through the ice because of unsafe conditions or carelessness.

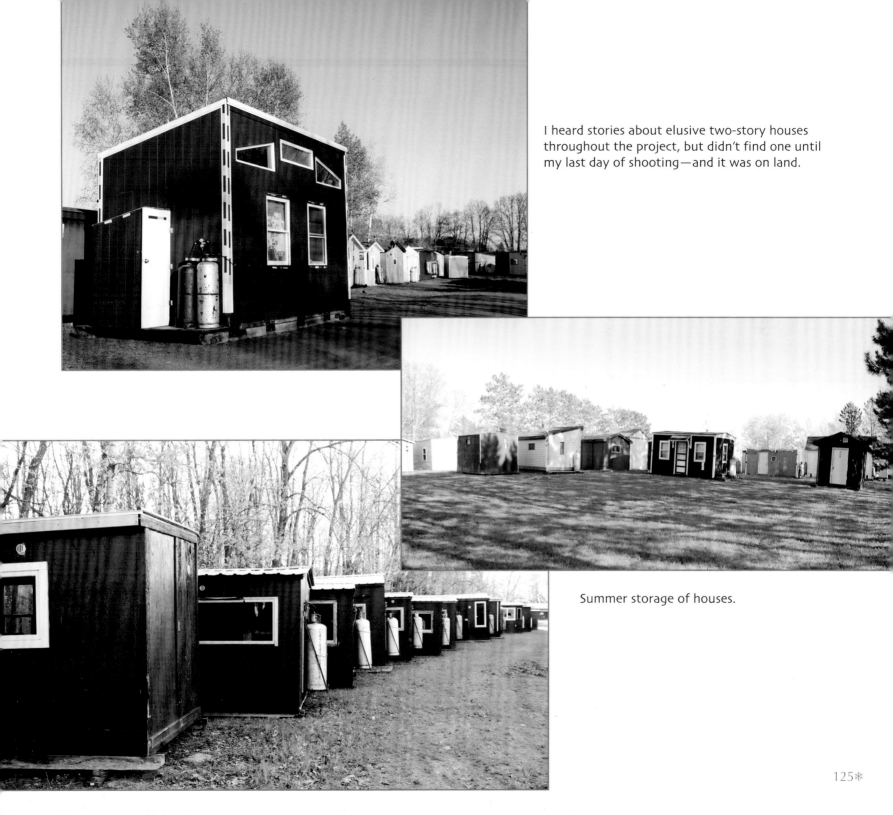

I heard stories about elusive two-story houses throughout the project, but didn't find one until my last day of shooting—and it was on land.

Summer storage of houses.

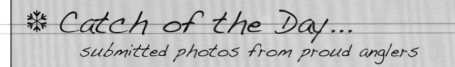
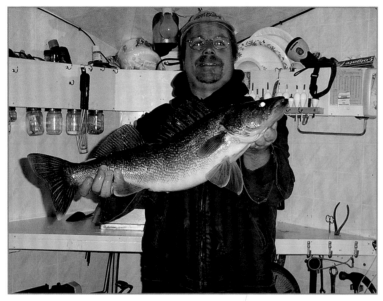

Randy Johnson, Roosevelt Lake, Outing, Minnesota.

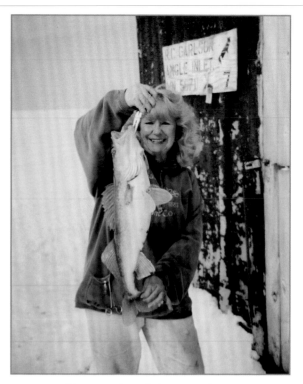

Janet Rafferty, Lake of the Woods, Minnesota.

Cole and Carter Peterson, Island Lake, near Duluth, Minnesota.

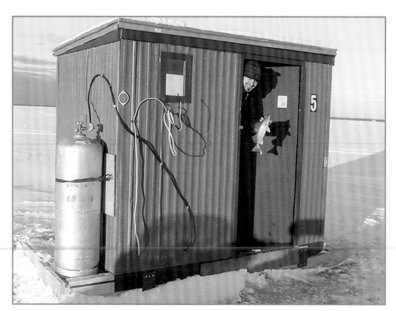

Blake Liend, Red Lake, Minnesota.

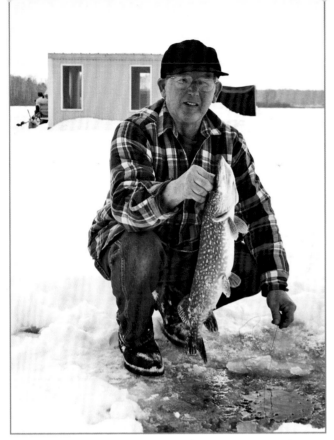

Melvin Waring, St. Croix Flowage, Wisconsin.

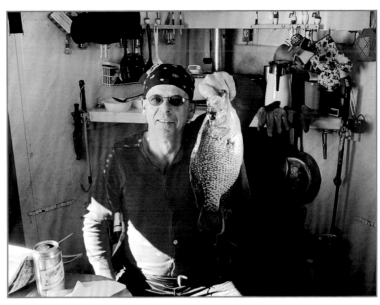

Jerry Kenning, Red Lake, Minnesota.

Al Anderson and Lexy Johnson, age four, with her first walleye, Pelican Lake, Brainerd, Minnesota.

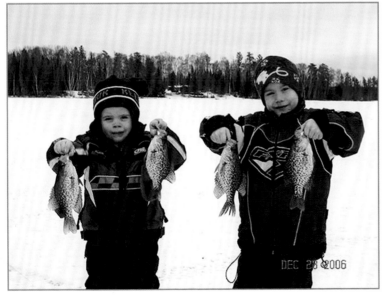

Braydon and Burandt Liend on Little Bear Lake, Minnesota.

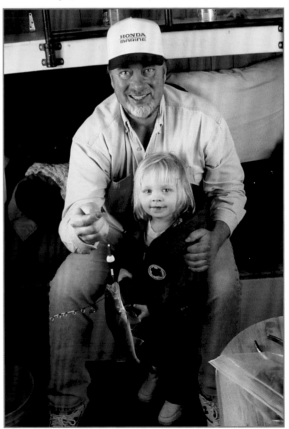

127✳

❄ About the Author...

Photo by Marlene Wisuri

Kathryn Nordstrom's interest in photography began when she was a child and learned to develop and print her own photographs in the darkroom of her family home. A life-long resident of Duluth, Minnesota, she studied photography and graphic design at the University of Minnesota Duluth. In 1995, she co-founded Studio One Photography in Superior, Wisconsin. Besides shooting portrait and commercial photographs, Kathryn works on personal photo projects that have recently included still life, nature, and figure studies. Her work has often been exhibited regionally and can be found in collections in the United States, Canada, and Sweden. Another great passion in her life is her love of horses. She has owned horses and ridden dressage for most of her life. Kathryn lives in Duluth with her son Brandon and dog Devika.